Photography Demystified

Your Guide to
Gaining Creative Control
and Taking Amazing Photographs

David McKay

Also by David McKay

Photography Demystified – Your Guide to Exploring Light and Creative Ideas

Photography Demystified – Your Guide to the World of Travel Photography

Photography Demystified – FOR KIDS!

A Kids Guide and Parents Resource for Fun and Learning Photography Together

As a thank you for purchasing my book, please click here to gain **UNLIMITED FREE** access to many photographic educational videos!

http://mckaylive.com/bonus

Unless noted, all images by Author David McKay
www.mckaylive.com/books

For orders, please email: mckaylive@yahoo.com

ISBN: 978-1-945176-96-8

This book is dedicated to all those who have a passion for capturing life through photography.

You are the inspiration for this and thank you for taking the journey with me.

Nick Sharples

Contents

Foreword

Most of you skip the foreword. For those of you taking the time to read this section: Thank you.

I want to take a minute to let you know who I am and why I am thrilled you have this book in your hand. I'm Toby Gelston. I founded photorec.tv where we produce gear reviews as well as photography tutorials.

In 2014 Photorec.tv partnered with David and McKay Photography Academy. We have joined them on a number of trips since as teachers and have produced videos and content to promote and showcase their trips. This partnership quickly grew into a close friendship and it has been a pleasure to work alongside and watch David and his wife, Ally teach photography.

As a master photographer, David exhibits the rare ability to both inspire and teach all levels of photographers. He is passionate about his craft and a patient teacher of the foundations of photography. On a recent trip, as the participants were setting up for photographing the sunset on a Greek Island, I asked a student which direction she was headed. Her response: "Wherever David goes. I know he is going to help me get the shot I want." Now you have in your hands his excellent teaching and a great foundation to the basics of photography. Get reading and I hope you will join us on a future trip.

Happy Shooting,

Toby (photorec.tv)

Introduction

Are you stuck on the auto mode on your camera? Frustrated by the fact that you know you own a great camera but are unable to use it to capture the photographs you've always wanted and that you "see" in your mind but can't get the camera to take? Did you purchase a new camera or receive one as a gift, excited about the wonderful possibilities of creating amazing photographs, only to open the camera manual and find yourself overwhelmed at all the technical information in front of you, thinking there is no way I can do this?

In this book, **I am going to get you out of "auto" mode and on your way to creating the incredible photographs you've always dreamed of!** This book will take you from automatic to full manual settings in a new and easy to implement way, giving you the control you need to capture images the way you desire. "Photography Demystified –, Your Guide to Understanding Photography, Gaining Creative Control and Taking Amazing Photographs!" has been designed to resolve your frustrations and photography difficulties. This book will give you the tools, education and practical applications needed to understand how to take great pictures! PLUS, a section entirely dedicated to assignments has been included! Video tutorials are also available at no charge: http://mckaylive.com/bonus/

Along with my wife Ally, I own McKay Photography Academy. Leading hundreds of photographic tours around the world, I have taught over twelve thousand people—just like you—how to excel in photography. Having earned my Master of Photography and Photographic Craftsmen degrees from Professional Photographers of America, the leading photography organization in the world, I have been a full time professional photographer for over twenty nine years and am passionate about teaching others how to achieve great results in their photography. My motivation is to see that everyone can enjoy photography and *take the frustration out of the process!*

Beginning photographers, camera buffs, photo enthusiasts, and many others who struggle with understanding photography concepts, exposure, and their camera manuals have already experienced my proven methods of teaching beginner's photography. **This book will do the same for you!**

Nick Sharples

- Terry L from Santa Cruz, CA says: "Taking someone off automatic settings to manual settings can be daunting at times. Fortunately, I have had the experience of learning from David McKay. David has taken me further into the world of photography than I could have ever imagined."

- Keith W from Austin, TX writes: "David is one of those rare individuals that combine passion, extensive knowledge and a laid-back style in teaching photography. What else can I say; it is refreshing to learn from someone this talented."

- Steve of Steve Scurich Photography in Santa Barbara,CA states: "The ability to take decades of complex photography knowledge and boil it down into concepts that are clear, understandable and easy to implement, is David's gift to the world. Personally, I am forever grateful for the inspiration and encouragement he's given me."

- Denise Mann from San Antonio, TX says: "David McKay is passionate about photography and equally as passionate about teaching it to those eager to learn."

- Jeff G from Sacramento CA says: "David McKay is a great photographer – not every photographer can be a great educator, David is! David is able to take complicated topics

and break them down to something easy to digest and practical to implement – you are inspired to go out and use what you just learned!"

- Kara from San Jose, CA writes: "You can't help but to feel his love for photography and his passion for teaching. Through his inspiring concepts he ensures your journey is captured through the lens of your camera."

- Eric and Janet from Arizona say: "On a recent safari in Tanzania with the McKay Group we had the time of our life. Not only was the scenery incredible, the McKay's and their instructors were absolutely wonderful. Starting with very little and I mean little experience; we ended the trip feeling like Photography Pros. It was a great way to see the world and learn photography too. We recommend it so much we have already signed up for another trip."

How to Use This Book

This book will help you understand in a very clear and simple way, what your camera manual doesn't. With that said, you will need to refer to your camera manual throughout the book as each reader will have various camera models that feature individualized locations for some of the controls and subject matter I refer to.

I developed this book with the very clear intent on taking you from understanding nothing—or very little—about photography, to being able to shoot on full manual settings and get great results! This book is broken into 9 sections. Within each section are various topics and how to' guides pertaining directly to that section. To get the most out of this book, I would recommend you go through it in the order. The temptation is to go right to the exposure settings. However, there is so much more to photography than just the exposure settings and included are many tips, and various insights into making sure that everything is laid out to help you to get the best results possible.

Also included are various **"Take Action Assignments"** geared towards getting you to actually practice what has been taught! Use each one of these as you go and you will find that by the end of this book, you will have obtained an incredible understanding of how to use your camera and how to take amazing photographs. **Please, do NOT skip the "Take Action Assignments".**

The final section of this book is dedicated to actual photographic assignments. I encourage you to take your newly learned knowledge and excitement and do these assignments in order. This will seal the deal as I like to say and you will be ready for the next book in the series!

The Art of Seeing

You are about to enter a world of "seeing." Photography is so much more than just "taking a picture". Sure, we take pictures, enjoy them and keep memories alive, but what about the rest of the process? What about the moments themselves that we are a part of during that single fraction of a second when that shutter is snapped? What about our feelings and emotions at that moment? What about the life events that transpired in that moment? What about the light, the smells, the seasons, the friendships, the family memories and so much more that makes up that singular moment of time?

For myself, photography is much more than just a picture. Photography is a way to share the world and my life with all those who see my images—to share my joys, my pain, my love, my emotion, my travels and the way I "see" life as it happens around me.

Steve Scurich

I truly believe that the reason social media is so huge these days—Instagram being one of the most popular—is that people love to share their life experiences and others love to discover life experiences through images. In some ways, social media has possibly distanced us from personal interaction. Yet, I actually think that in other ways, due to social media, we are able to be a part of each other's lives and know what is happening around us more than ever before. For myself, and surely for others as well, seeing an image of a longtime friend in a faraway location allows me a glimpse into his or her life. I think that is pretty special.

Before we delve into all of the "meat and potatoes" of learning photography, understanding exposure, figuring out what the heck a histogram is and much more, it is very important I share this essential idea. Photography without seeing would be like eating without tasting. What I mean by this is that anyone can gobble down a large portion of food and eat for the sake of eating. Sometimes we do that just because of the necessity for food in our lives.

However, when you truly take time to sit and enjoy a meal, savor the ambiance, sit with friends or family and have conversation, enjoy each nuance of the meal, you find that your dining experience is far greater than just stopping at a drive through. I want you to think of photography as an amazing experience. It is so much more than just snapping a picture. There is so much more that should go into that moment, and it all starts with seeing.

Whether you are using your phone or the latest and greatest camera available, taking in the moment, and all it has to offer, is really the foundation of a great photograph. Only then, from your heart, can you capture that moment that tells the story as you saw it and experienced it at that time. These are the images that will speak to others and these are the images you will cherish forever. Why? Because they contain emotion behind them. People will always connect to that.

Finding Your Photographic Voice

As a professional photographer with twenty-nine years of experience, there are times in my career where my voice has suffered. I do not mean my vocal abilities, but rather, my photographic voice; my ability to go deep within and through my work, to convey life moments, dreams, and scenes, in a way I knew was possible, yet could not seem to find.

Just as writer's block can set in for an author, there have been moments of photographic block in my life. Not the ability to take a decent picture, but the ability to find that passion within myself that drew me into photography in the first place. There were times when it seemed my passion to share with the world through photography had been quenched, times when inspiration had faltered, complacency had set in, and the day to day details of life quieted my ability to speak.

My hope in this book is not only to teach you how to see and understand the technical side of photography, but to stir in you a longing to get out there and seek and find your own unique photographic voice. In this hope, that you will find what it is in photography that makes you come alive and allows others to sense, within a photograph, your passion, joy, pain, perspective and the way in which YOU see things that no one else can. I want you to connect with that photographic voice that makes you—you! After all, isn't that the reason you take photographs? To capture moments? Moments as you see them? Moments as you feel them? Moments as you experience them?

Your voice should be as unique and individualized as you are. This is the first step in being authentic to <u>who you are</u> as an image maker.

As we journey forward together, always remember to learn how to "see" and "speak" which encompasses the very essence of what photography is: creating images that tell stories and are full of impact. Throughout this book, you are going to learn a great amount of technical skill, yet when it comes down to it, that skill must be applied to your emotion in order to truly photograph with the intent of capturing the story behind the image.

Passion and Skill—A Combination for Success

I am often asked what the key to creating a great image is. It is always interesting to me that those who have more of a technical type personality will tell me that technical skill is the key. These personality types tend to go into all the details of the math behind a lens, the analytics behind an f-stop opening, and how the menu systems in their cameras have so much to offer. Those with more of an artistic type personality tend to say it's all about feelings, emotions, and a great eye.

I want to pose these questions. "Can you make a great image with technical proficiency and no artistic proficiency, or vice versa? Is an image that focuses purely on the technical skill lacking in emotions, mood, or passion? Or is a solely artistic, deeply passionate image lacking in the proper technical skill?" The answer is, "Yes!" They both possess something, but they are both also lacking. The marriage of the two must take place. It is then that we can truly start creating great images.

I will be the first to admit that I am not very good at math and equations, and I am not a gadget nerd who takes every possible menu setting in my camera and dials them in for every situation. However, many people think and operate this way and are intrigued by all the options that are available in the world of photography. After all, the digital world has come about because of these types of thinkers. Where would we be today without mega-pixels, gamma rays and sensors?

On the opposing side of the coin, as it were, we find the more artistic type personality – those who tend to care less about the technical knowledge, menu systems, and dials used to create their images. You'll more than likely find them photographing in auto mode. They just want to enjoy the freedom to shoot from their heart, getting into the ambiance and the scenes that unfold before them.

So let's get back to the question at hand…what is the key to taking a great photograph?

My belief is that both the technical and the artistic go hand in hand to create a great photograph. I personally think that when a photograph is lacking one or the other, you end up missing a key component to a great image. Both the technical skills and the artistic components must be combined to make the best images!

Can you identify with one or the other? Here is some advice for each personality.

The Technically Minded

Those who are more technically inclined tend to need more help seeing, feeling, and being emotionally present to create an image that can convey both. They tend to need help learning how to rely a bit less on the buttons, gadgets, knobs, and every little digital detail. It can be difficult for them to let go for a bit and just enjoy and feel the moments as they come, the air, light, color, sounds, sensations, and nuances of a scene before them. Having asked these types of thinkers how they felt after photographing out on location, many times they answer with a question, such

as, "What do you mean felt? You mean when I was working with my camera, right?" They literally forgot to slow down and feel and take in the moment.

The technically minded need to make a conscious effort, many times with guidance, to let go of their constant analytical thinking for a moment and understand that they can actually make an image without studying the digital level or latest gadget in their camera. It takes time, but it's a habit that can be broken to create outstanding photographs.

A good way to become more proficient in the artistic side of photography is to take a moment before shooting to ask yourself these questions.

- What do I see?

- What do I feel?

- What do I want the world to see from my image?

- What do I want the world to experience emotionally from my image?

You need to be careful to not do this flippantly, but to take the time to look beyond the basic answer and work to find something that has more emotional depth. To make an emotional connection between what you see and how it makes you feel.

After answering those questions, take a moment to compose your image first. Then ask, does your composition reveal the answers to the questions you set forth? Then, apply your technical knowledge to the image. Choose the best f-stop, dial in your shutter, and enjoy your moment! Then later, after your images are downloaded, ask yourself the same questions of the images themselves. Did any of the photographs you took help you to feel that moment once again? That is the key component that you are looking for!

The Artistically Minded

The more artistically inclined person has a tendency to struggle with the details of f-stops, ISO and shutter speeds. They dislike all of the little "doo dads and gadgets"—so it's easiest for them to just use the auto mode and let the camera take control. When a tripod is suggested, you just may hear, "But I'm not free with a tripod." When one explains that freedom can be obtained through having more control over the camera settings, looks of frustration follow.

The "artsy" person has a harder time being bogged down by the technical aspects of photography. If they want to succeed with their photography, they will need to understand that all of the tools, techniques, and camera systems are just as important as having "a good eye", and that controlling them is certainly a process which can be learned so that they too can create stunning images.

By learning and understanding the basic exposure elements of ISO, shutter speed, and aperture controls first and foremost, the artistic person can come to understand the creative control and freedom they will obtain once they gain this knowledge.

For both types of personalities, and even for those who have learned how to combine passion and skill, there will always be challenges, but these can be overcome and the end result will be creating images that reach their fullest potential.

Nick Sharples

Light—The Key Word for Both the Technically and Artistically Minded

Although cameras have changed a lot over time, the most basic principle is still the same: light. It is the light that gets exposed onto a sensor or piece of film that creates an image. This basic concept is the first key to understanding your camera and how photography works. Think about it in these terms—You are painting with light. When you photograph a subject, you are really creating an image from light reflected off that subject. You are, in a very real sense, painting with light!

Learning how to control and harness light is a key we will be discussing during the upcoming chapters. Remember, light is essential to exposing images correctly and using your camera's manual settings. Without light, we cannot photograph. This principle is the key that enables us to take amazing photographs. Our images can succeed or fail based on lighting alone.

Later in this book, there are entire sections based on the technical exposure of your images, which is based totally on light. Without light, we have nothing in photography. There will also be assignments along the way to help you learn about shutter speed, aperture and ISO, the three elements of exposure. For now, just remember that light is our key word to unlocking the mysteries of exposure. When you combine that with strong composition, you can truly create amazing images.

Understanding Camera Designs, Preparation and the Correct Foundation

Just like many things in life, it is important to make sure your foundations are set in order to ensure the most success. I know many of you at this point want to rush ahead to the exposure area because that is a huge frustration for many people as they learn photography. However, before you do that, I want to encourage you to read through each of these chapters first.

You may be surprised to learn something you thought you knew already and to see how my approach to it may differ from what you previously thought. To this day, prior to ever going out and shooting, I take time to go through and make sure that everything is set and ready and that my foundation for what I want to accomplish is strong. I prepare each time I go out to photograph.

There is nothing worse than capturing great images and then realizing you blew it with something minor such as not having the best quality set on your camera! Be sure to read each of these points. Also understand that some of this is a bit "techy" but it is necessary for you to understand how to get the very best out of your cameras and for you to be able to take the best photographs.

Camera Design

First, let's cover a few basics about all cameras. All cameras contain the same basic elements: however, they may appear differently or work with minor differences. Nevertheless, the same principles apply. Here are the basic elements:

- Camera body or housing

- Light sensitive material

- Shutter

- Lens

- Viewfinder

Each of these elements is defined below. It is important to note that I will go into depth about each one of these elements so that you obtain a greater understanding of them individually. Some of this may seem trivial; however, it is important to receive a background and education on how the camera functions. Setting the correct foundation is the key to building. I want to make sure that your foundation is solid so that I can build upon this to give you the greatest benefits when it comes to learning photography.

- **Camera body**

 The casing that contains the entire camera's working parts.

- ***Light sensitive material***

 An element on which an image is exposed such as a sensor or film. The shutter and the lens combine to expose light to register the image. In a digital camera, this element is known as the "sensor." An image sensor is the equivalent to film for film cameras.

- ***Shutter***

 This is the part of the camera that opens and closes for a pre-determined amount of time to control how long light is allowed to enter the camera and expose the image sensor.

- ***Lens***

 An element that collects light and focuses an image on the light sensitive image sensor or film. Lenses are typically made of glass or transparent plastic. Glass will give you much better quality and lenses can be bought at a wide range of prices, based on the quality of the glass.

- ***Viewfinder***

 A viewfinder is what the photographer looks through to compose an image, and, in many cases, to focus the picture. A viewfinder is either the through-the-lens type or an LCD monitor, depending on the camera. Digital SLR cameras are usually through-the-lens with an eyepiece, while on more basic cameras' the viewfinder is through an LCD monitor.

Various Types of Cameras

With the advancement of digital photography, the world has been opened up to many various types of cameras. It can be quite confusing and intimidating to stand in a store and see all of the cameras lined up. Many of them look identical, yet the price difference can be hundreds, if not thousands, of dollars between various models. So what is the difference? Why do two cameras that look identical sometimes vary in such extreme costs? This is why it is important to understand camera design and what the manufacturers are trying to sell to you, the consumer.

First, you must understand that to gain creative control, you need a camera that allows you to adjust the manual settings.

This means that you can control the three elements of exposure you will be learning about in the "Elements of Exposure" chapter. These elements are the ISO, the shutter, and the aperture. If your camera does not feature those manual settings, you will be unable to make the needed adjustments to harness the light for what you want, rather than what the camera wants. You will find that this is the key to being able to control the aspects of your photography outside of composition.

DSLR, Mirrorless, Point and Shoot, What Does it All Mean?

DSLR—Digital Single Lens reflex

In the reflex design, light travels through the lens, then to a mirror that alternates to send the image to either the viewfinder or the image sensor. The viewfinder and what you see through it, presents an image that will not differ from what is captured by the image sensor.

Most DSLR's contain full manual settings. You also get the ability to change lenses with a DSLR. This is much better than built-in lenses as the quality and your creative ability to control and manipulate your images according to preference is far greater. A DSLR camera also has no delay when pressing the shutter button. In other words, when you press the button, the image is taken instantaneously. No more missing the shot as you wait for the camera to take the picture!

DSLR cameras are typically more expensive, but offer a much greater ability to control the results of your final images. There are several brands that manufacture exceptional cameras in various price ranges. Canon, Nikon, Sony, Olympus, Pentax and others all offer great DSLR cameras. Canon and Nikon tend to be the most popular and are highly respected brands.

Mirrorless

Mirrorless cameras have a system with an interchangeable lens that does not feature a mirror reflex optical viewfinder such as in the DSLR. Mirrorless cameras are designed with the advantage of smaller size and lighter weight. They frame using what the sensor sees rather than using optical views, with exchangeable lenses.

This is the fastest growing segment of digital photography at this time. This is due to the fact that you can get an amazing quality system, with less weight than a DSLR in many cases. All the manufacturers are producing these nowadays; however, Sony, Pansonic, and Olympus are in the forefront with Sony far ahead of the game as the leader in mirrorless technology and quality.

Point and Shoot

At the lower quality camera spectrum that can still give you great results and even include manual settings, are the point and shoot models. These are a great value. They are geared towards the person who does not want to spend a lot of money, yet wants the ability to gain some control over the photography. They do not include the ability to interchange lenses; however, they can be a low cost, excellent quality alternative. They are also very easy to take with you anywhere!

As a general rule

Another important note is that cameras, just like computers, are becoming outdated much sooner than they used to. However, a good camera can and should still last most people for years. One thing you will find is that lenses become the item you tend to hold onto for a life time. The camera bodies themselves, much like any other electronics these days, become what you change out every four to five years based on new technology available at lower costs than ever before.

RAW vs JPEG

I shoot both RAW and large JPEG files at the same time (my camera allows this). I use the JPEG to preview the images as RAW is such a large file that viewing programs such as Windows Media either take forever to load each image or are not able to read the data. The images that are my favorites, I then take and convert using software such as Adobe Camera RAW or Lightroom to work on during the editing process.

The bottom line is that if it's something you want as a possible high quality image and you want to produce the best image quality possible; RAW is the way to go! At the VERY LEAST, use your cameras highest JPEG setting.

When you're setting up your camera files, in the menu you'll notice that there are a number of files that you can choose from. You'll see RAW and you'll see large, medium, and small JPEGs. If you own a Nikon or Sony, it will say fine for the largest JPEG and normal and basic for the others. Canon will be RAW +L

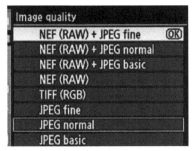

Nikon

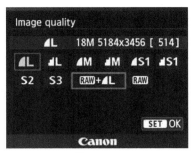

Canon

It's important to understand what RAW data is. When you take a photograph on RAW, the data is simply a huge amount of digital information that's coming in and recording to your memory card. The data is recording, but it's not actually created into an image at that point. It's just raw unfiltered or compressed data.

When you set the camera up to shoot on a JPEG, the camera converts that RAW data into an image file. For instance, you can email that image right out of the camera or you can work on that image right out of the camera. Here's the problem. The camera is converting all that RAW data into whatever size JPEG you've set up. In doing so, it's throwing a TON of the important data away.

Shot on Large JPEG

Shot on RAW

Notice the loss of detail in the highlights! That is a LARGE amount of loss!

You may be thinking, I don't know how to work in Photoshop or I don't know how to work in Lightroom, so I don't know what to do with that. I'm going to encourage you to set your camera up to shoot on RAW plus a large JPEG and here's why.

Perhaps at this point, you don't know how to work in Photoshop or Lightroom. What about six months from now or a year from now? You might find yourself, all of a sudden, learning how to work in one of these programs and you go to work on your image and you realize that you don't possess all the data you wish you had. That image quality is going to suffer. It's a real bummer when that happens and I've seen it happen a lot with people that start wanting to print their images and it's just not the quality they could have had.

Set your camera up to shoot on RAW *plus* a large JPEG. (See ex. above) Many photographers just shoot on RAW or just on JPEG. The reason I want you to shoot on RAW plus the large JPEG is this: if, for any reason, something should happen to your card, and believe me, I see that happen, there is a greater possibility of recovering the JPEG image even if image software is unable to recover the RAW data.

If your card goes bad, the software that's available today to go in and recover images can't always pick up the RAW data. If that data has been converted into a JPEG, the software has a much easier time recovering the images. So, at the very least, you would still get a high quality JPEG to work with. This is why it is smart to shoot on both files sizes. You will notice it uses a lot more memory to shoot on RAW, however, that should also make you realize that if a lot more memory and images are available when you are just shooting JPEG vs RAW, then a lot of image quality has been lost. It means the camera is not using nearly what it could be to create an image, which means your images are not as high of a quality as they could be.

Just as a side note here, again. When you're setting up your cameras, make sure you go into the menu system, look for RAW and JPEG, and set your camera up with RAW plus a large JPEG. In Canon, that will be RAW with an L. In Nikon that will be RAW plus fine.

You'll find that you're going to be much happier with the end result of your images when you start working those images of the highest quality in software such as Photoshop.

> **Take Action: In your camera menu system, find the various RAW and JPEG settings available. Set your camera at a minimum to the largest JPEG. However, remember what I recommend above about RAW and JPEG being used together.**

White Balance

In your camera you can find what is known as white balance. It will simply show a WB button or may be located in the menu system. This stands for white balance. What is white balance? It all comes down to the concept of color temperature. Color temperature is a way of measuring the quality and tonality of a light source.

It is based on the ratio of the amount of blue light to the amount of red light, and the green light is ignored. The unit for measuring this ratio is in degree Kelvin (K). A light with higher color temperature (i.e., a larger Kelvin value) has more blue lights than a light with lower color temperature (i.e., a smaller Kelvin value). The following table shows the approximate color temperature of some light sources.

- Light Sources—Color Temperature in K
- Clear Blue Sky—10,000 to 15,000
- Overcast Sky—6,000 to 8,000
- Noon, Sun, and Clear Sky 6,500
- Sunlight Average—5,400 to 6,000
- Electronic Flash—5,400 to 6,000
- Household Lighting—2,500 to 3,000 200-watt Bulb 2,980 100-watt Bulb 2,900
- 75-watt Bulb 2,820 60-watt Bulb 2,800 40-watt Bulb 2,650
- Candle Flame—1,200 to 1,500

The human brain can quickly adjust to different color temperatures. More precisely, our eyes, with the help from the experience we've had, see a white paper as a white paper no matter whether it is viewed under strong sunlight or in a room illuminated with incandescent lights. *However, the camera does NOT see white as true white in various lighting conditions.*

Digital cameras feature built-in sensors to measure the current color temperature and use an algorithm to process the image so that the final result may be close to what we see with our eyes. But, the algorithm(s) being used may not be accurate enough to account for every situation.

Under some difficult situations, when the in-camera algorithm is not able to set the color temperature correctly or when some creative and special effects are needed, we can instruct the camera to use a particular color temperature to fulfill our need. This adjustment makes sure that the white color we view directly will also appear white in the image is referred to as white balance.

Years ago, it was common to use a filter over your lens to help make the adjustments. For instance, if you were shooting in a fluorescent lit room, you could place a fluorescent filter on and that would help adjust for the color tone differential on your film. In today's digital world, the

advantage of being able to adjust right in-camera for every situation that may occur is right at our fingertips.

WB Pre-sets

Cameras today are equipped with a number of pre-sets you can use depending on the light you are in. AWB, or auto white balance is much better than it used to be in the early digital days. It can and usually does provide decent results.

It is also important to note, that with today's software such as Lightroom or Photoshop, it is very easy to change the WB should you forget to adjust it during your photography time. So do not fret if the color on your images is a weird color cast or if you forgot to change the WB prior to shooting. This is also something that you can learn later in basic editing. For now, just use auto white balance (AWB) if you are concerned about adding an additional task.

People often ask me what pre-sets I use for white balance. For starters, I try to very rarely use AWB as I like to teach people to try to make their images as strong as possible out of the camera first. As much as I love the editing software today, I prefer not to have "fix it" later mentality. Condition yourself to always shoot as accurately as you can to begin with.

My friend Jeff jokes that AWB stands for Always Wrong Balance. This is because the color tones do not tend to be great in auto white balance mode. You may have noticed this in your own images.

The absolute best WB to learn how to do is a custom white balance using a simple white card that is used for setting your white balance. Every camera is different in how you attain the custom WB and your manual (yes, you must refer to it here) will show you how.

The idea is that you are simply taking a photograph of a pure white card in the light you are in, then telling your camera to adjust for that white in that light condition. This proves to lead to optimum results and I try to use this as much as possible when photographing portraits outdoors where skin tones can really be affected. You MUST learn how to do it specifically for your camera system.

However, for nature and landscape shooting or anything that needs to be done quickly such as street photography, I use the WB pre-sets and find that they are really good these days requiring little or no adjustments after the fact.

Shot on Auto WB

Shot on Sunny for WB

Here are the typical pre-sets available:

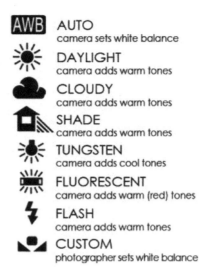

AWB AUTO
camera sets white balance

☀ DAYLIGHT
camera adds warm tones

☁ CLOUDY
camera adds warm tones

🏠 SHADE
camera adds warm tones

💡 TUNGSTEN
camera adds cool tones

FLUORESCENT
camera adds warm (red) tones

⚡ FLASH
camera adds warm tones

CUSTOM
photographer sets white balance

It is a pretty simple and straight forward explanation. Simply choose the WB for the setting you are in. If you are in sunny conditions, use the sun, if you are in cloudy, use the cloud and so on.

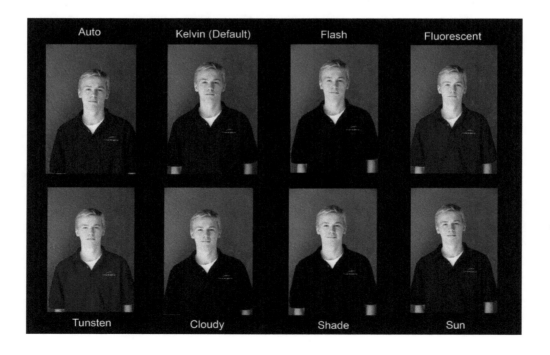

As you can see from the sample above, various WB settings give drastically different results. I experiment with other white balance settings based on the scene once in a while as well. For instance, when photographing at night and with buildings that are lit, I will sometimes test the results I get with the incandescent setting as it can be more dramatic.

However, for most scenes, I think the sun pre-set works great in bright light and cloudy pre-set works great in overcast and shady areas. It also works great in window light.

By using white balance correctly, you will get much better tonality in your images and save HOURS of post-production work in editing.

> **Take Action: Take a moment to learn how to change your white balance in your camera. Usually, there is a simple quick way to get to it. On Canon, typically there is a WB button on the back or top. With Nikon, usually you can push the info button which opens up a quick menu system to where you can get to the WB quickly. Always refer to your camera manual and white balance to do this quickly and efficiently. Choose AWB for now but as you advance, change your WB for the scene you are shooting.**

Focus Modes

Auto focus is very reliable in todays' camera and lens systems. I spent many years having to focus manually and originally auto focus was slow and not that good. On your lens itself, you will see an A and an M. The A is for auto focus, which I highly recommend. The M is for manual focus. DO NOT confuse this with manual settings for exposure that I will be teaching you soon. In today's systems, I trust the auto focus more than my own eyes! However, there are various focus modes that are used for different subjects you may be photographing.

On Canon, there is what is known as one shot. There is AI Focus mode and there is AI Servo mode. On Nikon or Sony systems you will see the same modes notated by AF-S (one shot) or continuous focus notated by AF-C. The other systems also have their own terminology for doing the same thing.

One Shot Mode

As you depress the shutter button halfway, the lens begins to focus. The focus will "lock" onto your subject and as long as the shutter remains pressed halfway down the focus will remain locked. The second you release, it refocuses. I tend to use the one shot for approximately 90% of my photography. I love this for one reason. When I am focusing on a subject and I want that subject in

maybe the left third of the image compositionally, versus the center, for an example, the camera tends to focus beyond the subject and it's not going to be in focus. To rectify this, the one shot system will help.

I can simply focus on my subject by placing the center point on my main subject, and then when the lens locks on my subject, by holding down the shutter, it stays locked and it's ready to shoot. I can then move parallel to my subject and take my photograph. It will not refocus as long as I'm keeping the shutter button it halfway depressed. Simply focus, lock and then move and take the photograph. That way the camera's not refocusing back behind your subject. That's a great way to work with the rule of thirds composition you will be learning about.

When using this technique, you need to be careful that you're not moving your depth, because that will change the distance that your subject into your camera is focused, so simply move sideways, parallel to your subject vs front to back.

Continuous Focus Modes

AI focus mode or continuous focus modes are used for action photography such as sports or wildlife. When you put it on the AI mode, let's say AI Servo on Canon or AF-C on Nikon, the camera continually focuses on a moving subject. The reason this mode will not work for a subject that is not moving as we did above, is that if you want to recompose the camera for your composition after focusing, the camera will not hold focus and continually refocuses to where the center of the lens is pointed. With a continuous focus mode, the idea is that as you focus on a subject and that subject starts moving, as long as you are pressing halfway down on the shutter again, you can follow that subject and the camera will continuously focus on your subject. Again, this is great for sports and wildlife. As an example, if you are photographing in Africa and all of a sudden there's a lion moving across the plains, you can focus on that lion and as it moves, you can move with it and it will keep focusing.

The downside of this system though is that anytime a different point of contrast comes in front of your lens for example if another animal moved in front of the lion you were focusing on, the camera will pick that up and start focusing on that subject. If you're not careful and you don't notice what's happening, your images may not be sharp. You want to be really careful with this. In either mode, anytime I am photographing action or sports, I will shoot in burst, focusing each time to be safe.

Let's just do a quick recap. One shot is your focus; the camera locks in on your subject, and as long as you're halfway down on the shutter, it stays locked. You take your photograph. If you want to put the subject in a different portion of your image, you stay locked on the subject and can simply move and then take your shot. Use a continuous focus mode for fast action sports or wildlife and moving subjects.

Focus Points

Autofocus points are what the camera uses to focus on a subject. You will immediately notice them when you press down on the shutter as they will light up on the area that is being focused.

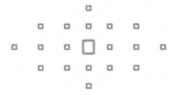

Autofocus selections that use all the points of your system have become much more sophisticated in the last few years and are becoming quite effective. However, with certain types of subjects, it can be useful to simply use a single point by changing the points in your camera to a single point. (See your manual to change points)

By using a single point versus the full point system, you can choose a precise area on which to focus rather than the camera choosing based on where the lens is pointed. This is a great way to change the point to the exact spot you want in focus, especially if you are working with a shallow depth of field. (See Depth of Field ahead)

I shoot on single point. I do this because I want to make sure that the most important part of my subject in an image is the one that is the most focused rather than allowing the camera to choose that for me.

Camera Diopter Adjustment

Cameras usually come with a diopter which allows you to calibrate the viewfinder to match your eyesight. It is very easy to adjust your diopter. Focus your lens using the autofocus in your system. Now, look through the camera while turning the little dial or knob found next to your viewfinder (the one with the +/-). Once the scene is sharp to your eye (as long as the lens is focused), you are ready to go. It is important to note, that this will not adjust the actual focus of the lens. You are simply setting the viewfinder to match your eyesight. Similar to if you were sharing a pair of binoculars where you would change the center diopter ring when going back and forth with another person; this is operating much the same way.

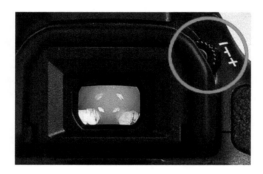

Take Action—Focus your camera in autofocus and when the camera "locks" in; adjust your diopter for your eyesight.

Memory Cards

I often wonder with memory cards being so inexpensive in today's digital world, why people try to save a few dollars and buy a less expensive, unknown brand, and slow writing cards, just to save a few bucks. Film was and still is MUCH MORE expensive. What good does it do to spend thousands of dollars on equipment, save for years to go on a trip, and then trust it all to a cheaper memory card to save twenty dollars? I am going to spend some time here in this chapter. This is such an important part of today's photography, and yet, I cannot begin to tell you the amount of sad stories of lost images from people who do not listen to what I say. Your photography is only as good as your images are safe. This is one of the most important chapters in the book!

As a photography tour leader, I take many students out on photographic tours to various locations around the world. I've noticed another issue that I want to address. Since memory is key to capturing images in digital photography, I've noticed that many of our students are purchasing large GB cards (such as a 128GB) in hopes of using only one card on a trip. Although this may sound like a great idea and it is more convenient, there is a risk in doing so.

You are putting all your eggs, or rather images, in one basket! If, for any reason, you lose that one card, ALL of your images are gone. This reason alone is why we would never photograph an entire wedding, for example, or trip on one card even if the memory allows it.

Cards can and do go bad! The dreaded "error" message can appear which can be a sign that something is wrong with your card. Memory cards might not contain any moving parts, but that doesn't mean they don't wear out. On the contrary, they each have a finite life, and every time you write to, delete from, or read the card you're bringing it another step closer to the end of that life. If you don't want to risk corrupting your pictures far from home, replace heavily used cards every couple of years.

If a card goes bad, it does not mean you've lost all the images. However, it can be EXTREMELY expensive to pay a company to retrieve them for you. Even cards that are dropped in water can sometimes have the images pulled from them.

The more data on a card that is being used, the slower it writes. This means, that as you are taking images, it may take longer to write the image to the card. Try not to use a card all the way to FULL CAPACITY. It is not good for the cards and you will find it writes MUCH more slowly the fuller it gets.

For these reasons, it is HIGHLY recommended to use a few different cards on any trip or anytime the images are important. I also HIGHLY recommend that at the end of each day of shooting, you make SURE to back up your images to TWO different locations.

When you've saved and saved and spent a large investment on a trip and on your photography gear, to photograph what matters to you, and to create lasting memories and images, losing your images is not an option. Have you thought about taking precautions to help make sure your images are safe after the shutter is pressed?

Many people cringe at the thought of losing their images while traveling or any other time for that matter and think this will not happen to them. Unfortunately, the reality is that many people lose their precious images.

Has your memory card ever suddenly decided to give you the dreaded "error" notice? Maybe your new back-up hard drive failed or possibly you simply lost your camera bag by leaving it in the over-head bin of the airplane. Sound familiar? Maybe one of these situations has happened to you or perhaps one of the many other possibilities that can ruin all of your dream trip photography has taken place. No, you say? It hasn't happened to you yet? GREAT! This means that up until this point you are fortunate or, hopefully, properly prepared.

The saying "those who back-up and those who will" comes to mind. I've led photographic tours all around the world; the amount of times images are lost by photographers is truly staggering.

Don't let it happen to you! After all, some would argue that the most important part of their trip is their images. So, why don't people take more time to protect the fruit of all their investment and labor—their images?

Here are some helpful tips and hints to keep your most precious commodity of your travels, your images, safe.

- **Get into a system**—Create an organized system and do not waiver from it! Follow the hints below, set up a system, and be consistent.

- **Keep non-downloaded cards unique**—In your card carrier case; keep all non-downloaded memory cards backwards and upside down. In this way, you know the card is not ready for use. When you download AND back it up, at that time place the card right side up again. It is now ready to use.

- **Format your memory cards**—Before each use, INCLUDING the first use, format and make sure your card is clean. This makes sure the card is completely ready to go. Of course, only do this if all of your current images on the card are downloaded AND backed up! When erasing images, there is often still data left on the card and it is not truly clean. By formatting the card, you are erasing the card completely and making sure it is clean, which results in better performance.

- **Don't put all your eggs (images) in one basket**—Simply put, do not buy the largest memory card money can buy and shoot your entire trip on one card. If you lose a card or one goes bad, you will at least have a portion of your trip images left.

- **Bring PLENTY of high quality memory cards**—Memory cards are drastically lower in price. Do not shoot all your images on one card, invest in plenty of memory. It makes no sense to spend thousands of dollars on a trip, gear and more only to skimp a few dollars on what holds the memories!

- **Download and back up every day**—Once you return to the hotel room, you may be tired, but your images are worth the little extra effort to download immediately and then back up to a secondary device.

- **Always carry an external hard drive**—As soon as you download to your laptop, be sure to back up to an external hard drive as well. The price of memory is so inexpensive; there is absolutely no reason to not be carrying a lightweight external hard drive.

- **Carry your used memory cards on you physically**—This reduces the risk of loss due to theft, leaving your gear by accident, or in case you must check your gear for any reason either on a flight or gate check.

- **Don't erase your images**—Unless you are out of cards to use and it is absolutely necessary, do not erase the images. If you are downloading and backing up, now you hold

them in three locations. If you follow the hint about having plenty of memory, this should not be a problem.

- **Use the dual card slot on your camera**—Some cameras feature dual card slots. The Canon 5d Mk 3 for example, allows you to use a CF card in one and an SD in the other. When you shoot, the system can be set to write to both cards automatically. This is great, yet it does take longer to shoot as it requires a longer write time. This is no excuse for NOT following the other hints.

- **Shoot RAW and large JPEG files**—The recovery software available cannot recover RAW data as easily as a JPEG. For this reason, if you shoot with both RAW and JPEG, the likelihood of being able to recover images if a card goes bad is higher. You may not get the best image if you lose your RAW data, but at the very least you will have a high quality JPEG, which is still great quality. This of course requires more usage of memory, so once again, carry plenty of cards!

- **Partner up**—If traveling with another person or group, buddy up with a partner to carry your external hard drive of back up images and you carry theirs. In this way, your images are on you physically (on your memory cards and laptop), and then in case something happens, another set is with another person.

- **Contact info**-Be sure to write your phone and email address on all of your memory cards, hard drives, laptop, card carrying case, and camera bag.

- **Store a back-up of your images offsite**—Answer this question. If you were away and there was a fire in your home, would you possibly lose your images? If the answer is yes, then you've got some work to do. Carry a back-up of your home computer hard drive with you or keep one at another location. Also, keep hard drives in fireproof safes.

This is a photo of a fire as it roared towards our home. We take saving our images very seriously!

- **Use online storage**—Many companies such as Dropbox, Carbonite, Amazon, and more offer excellent, inexpensive online storage solutions. The issue is that while traveling, internet connections may be poor and it can take forever to load your RAW images or large files.

- **Card Sharing**—Do not share cards between cameras! There are people who say that it does not matter. Our experience is the opposite. Anytime you are taking a card that has been used in a camera system, and introducing it to a different system, due to all of the software involved, there is no guarantee that something may not go awry. For this reason, we do not share cards, for example, between a Nikon and a Canon.

- **Brands**—There are many brands available. We always purchase the best of any brand. After all, your memories can never be replaced! Companies such as Sandisk and Lexar are very consistent in their quality.

Write Speed

I recommend purchasing cards with higher write speeds. If you are tired of watching your LCD "writing" after you take a photograph, chances are, you did not purchase a very expensive card and it has a slower write speed.

Memory card speed is the card's performance with regard to how quickly data can be transferred to or from it. The card speed is often indicated by rate (12X, 40X, etc.) or sometimes more specifically in megabytes per second (MB/s). By today's measure, less than 20X represents a standard speed, 20X to 40X is mid-high speed, and over 40X is high speed.

Why do we need different or higher speed cards? This is mainly due to the advancement of our digital devices, especially digital cameras, camcorders and music devices. As manufacturers develop higher spec devices (i.e. higher resolution cameras), they are creating increasingly large amounts of information to store pictures, movies, music and so on. This, in turn, takes longer to record onto the memory card. For example, if you've ever used a high mega-pixel camera with a standard speed card you may notice a time lag between pressing the shutter button and being able to take the next picture. This delay in most cases is caused by a slow write speed. Similarly, copying your photos to your PC could take time too and is caused by a slow read speed.

> **Take Action: Make sure all of your images are downloaded AND backed-up to an external hard drive as well. Get your download and backup system working and ready! Write your contact information on each card or card holder. After completing the download and back-up process, make sure to format your memory cards.**

The Elements of Exposure

Up until this point in the book, everything has been set up to get you to this crucial point, exposure control and the elements of exposure! This is where you will now learn to gain the creative control you want. If you jumped ahead to this spot (I know some of you did), I want to encourage you to go back and make sure you read over the first several chapters and sections as well. They are vital if you want to get the most out of your photography. With that said, I also know that this area is the biggest struggling point for new photographers. Many people obtain amazing camera systems and yet never utilize them to their fullest potential, relying on the camera itself to get them the image they are hoping for by setting their mode dial to Auto Mode. Unfortunately, as most people find out, this rarely gives you exactly the kind of picture that you imagined and had hoped for!

The Question That Must Be Asked

Here is a question that I ask all of my students in our classes when they are first learning—Does the camera know what your subject is? The answer is no. The reality is that the camera has no idea what your subject is, only you do. With that, how can the camera then make the proper judgment for what your exposure should be for that given subject? The answer is—it can't.

I know I know, some of you are saying, "But I don't use auto, I use the scene modes!" The theory behind this is that you change your mode dial to the little scene figures such as "Sports" or "the Mountain", or "the Head" based on your subject.

Here is another set of questions. Let's say for example, you are photographing a sport such as soccer. Does the camera know if you are photographing five year-olds or eighteen year-olds? Does the camera know who is faster? Does the camera know how fast the ball is being kicked? The answer, of course, is no.

This is the telling reason why a scene mode such as sports mode, will give you results that are all over the place. Sure, you will get some good ones. You will also get a lot of bad ones. Now, let's say you keep the camera in sports mode, but go into a gym to photograph basketball. Does the camera know that you are now photographing basketball? Does the camera once again know the ages of the athletes? Or how about this, does the camera know you are in a gym with fluorescent lights? Of course the answer, once again, is no.

I have asked "Have you tried sports mode?" hundreds of times in my classes and almost 90% of every class has. My next question is always "What were you trying to photograph?" I receive just as many different answers every time I ask it. I've heard many sports such as soccer, football, baseball, hockey and the list goes on. However, I also hear answers such as my toddler, whales, and pets. My wife and I literally hear tons of answers all over the board to this question. YET, people are still stuck on the sports mode in hopes that it will capture what they want.

I know what they are thinking and what you may be thinking as well. The thought that if there is some kind of action, whatever it may be, it MUST be in sports mode because that is the only one

closest enough to what you are shooting to make any sense. Yet, the reality is that every subject can be different and there are MANY factors that come into play when it comes to getting great photographs.

Here is the key. The camera knows one thing. The camera knows light. However, the camera does NOT know the exact subject you are photographing. I stated early on that light is the key to photography. This is where the rubber meets the road. This is going to open up an entire world of creativity and control that will allow you to be able to get the amazing photographs you know are possible with your camera!

The reason that the camera cannot get the result or at minimum gets marginal results on the scene modes is not entirely because of your subject. It IS because of the light available for the subject you are photographing! THIS IS KEY!

How Light Changes Everything

Photography is all about light. Light is valuable and the key to creative control is learning how to control and work with light in our cameras and lenses! Sometimes you may find you have too little light. Yet at other times, you will have too much. I am going to teach you the process of learning to work with the light and your camera's manual settings to control the AMOUNT of light exposing the sensor. The reason the scene modes struggle so much, is that the camera manufacturer knows you are working with some type of action, so they set a pre-supposition to that in that mode. Yet, because of all the factors involved, the results are often mixed.

Usually, the biggest reason that the images do not work out is because of the amount of light available. For example, shooting a soccer game on a very bright day affords you a lot of light. You are going to learn that the key to stopping action is known as setting a fast shutter speed (more to come on that later). Yet when the shutter opens and closes very quickly in an exact fraction of a second in time, very little light can get in. If the day is really bright you will find it is no problem because even though the shutter opens and closes extremely fast, there is enough light to handle it.

Now, let's assume that you go into that low lit gym to shoot basketball. You still NEED the fast shutter to stop the action, yet with a fast shutter there is not enough time for the light to come in as it is not very bright. This is where the camera adjusts the shutter to stay open longer to acquire the needed light. YET, in doing so, the action becomes blurred as the shutter is open too long. This is just one aspect of one scenario, but there are thousands of scenarios out there that you may be photographing. Wouldn't it be great to know how to make the adjustments YOU need and the adjustments YOU know will work for the subject you are photographing? I am here to teach you how to obtain complete creative control in every scene and every situation.

Yes, it will take practice and work, but in the end, you will receive so much more ability to get these amazing images that you are capable of.

It is not the camera that takes a great photograph, it is the person behind the camera!

Nick Sharples

Exposure Overview

Exposure control means having the *right amount of light* to expose an image and is based on three major elements; shutter speed, ISO and aperture/f-stop. These three elements are the essential keys to understanding the EXPOSURE and CONTROL of the camera on the subject that you are photographing. All three work separately to create certain elements in an image, such as stopping action, for example. Yet they all *work together*, at the same time, to control the amount of light needed for an image to be properly created. Once you learn these three exposure control elements, the world of photography will open up to you in a way that is unlike anything you could ever do with a camera in automatic mode.

You will come to understand that you can use many combinations of these three elements or settings to achieve the same exposure (amount of light). The key, however, is to know which trade-offs to make, since each setting also influences other image properties and the character of the image.

For example, *aperture/f-stop affects light AND depth-of-field. Shutter speed affects light AND motion. ISO affects speed, light AND image noise.*

The next few sections will describe how each setting is specified, what it looks like, and how a given camera exposure mode affects their combination. At this point, you may be concerned as to whether you can actually do this. I am here to tell you that without a doubt, you can! I have taught literally thousands of people my methods for understanding a complex system and helped to make it much easier to understand to get the results you want! Don't worry! I've got your back here.

Here is how I'm going to do this. I am going to break down each individual element into bite-sized pieces after teaching you the exposure triangle. I will discuss just that element and focus on that one only. Now, as stated above, all the elements are always working together. Yet, rather than throw them all at you at once, we are going to learn specifically about each one and its individual properties. This way, when I do bring them all together, you will understand exactly what is happening. I am about to unlock and demystify photography for you to give you creative control! I hope you are excited!

The Mode Dial

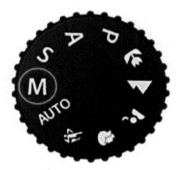

Cameras that use manual settings usually feature a mode dial similar to this. If your camera has manual settings, but not a mode dial, that simply means they made it an electronic dial built into the system. Each letter or symbol on the dial places the camera in a different mode.

Scene Modes

These are the symbols in picture form such as the "Running Man", "the Head", "the Mountain," etc. As discussed, these are NOT the way to gain creative control in your photography. They simply are placed by the camera manufacturer to provide a quick way to shoot various types of scenes. However, as we mentioned, they are rarely very accurate based on the fact that there are so many variables to every scene you may encounter.

Automatic Modes

In Automatic or Program (P) modes, the camera relies on the light available to create an image. This holds the advantage of the photographer not having to think about or understand what is happening to create the exposure. HOWEVER, by always relying on the camera to do this, you put yourself at the HUGE disadvantage of not being able to create the images you might like to create. As we discussed, the camera does not know what you, the photographer, are trying to create. Therefore, it manipulates the exposure based on what it believes is the best use of all three exposure controls for the situation.

S or Tv: Shutter Priority

The S or Tv (Time value) mode on your camera stands for shutter priority. The reason the word priority is being used, is because you are choosing the shutter and allowing the camera to control the other settings. In a sense, you are prioritizing the shutter over everything else. In this mode, at the very least you are taking some control. Some control is better than none and this is a great way to get started as you are learning to, at the minimum, control some aspects of your image. In this mode, you are given the control of the shutter speed. You simply choose the shutter speed you think is good for the image you are taking, and the camera will do the rest. We will discuss in detail when this is a good option and why it is not always the best option. As we've already touched on, shutter speed controls light and movement.

A or Av: Aperture Priority

The A or Av (Aperture value) mode on your camera stands for Aperture Priority. As with the shutter priority mode, this is a semi-automatic mode. You simply choose the aperture or f-stop (they mean the same) you prefer, and the camera will take care of the other settings. Once again, some control is better than no control. Many instructors start their students off in this mode. I will explain the advantages, but also the many disadvantages and precautions to be aware of when shooting in this mode. I previously mentioned that aperture/f-stop is used to control light and depth of field.

M: Full Manual

This is the full manual setting. Here you can control all three elements in your triangle. This is where you truly gain full creative control. This is really what you want to learn. My goal with this book is to get you off of auto modes and into full manual. With that, you will truly experience being able to capture images the way you want. Sure it will take some practice, but the advantages are well worth it! You MUST be on the M setting to change the functions that we are going to discuss in detail.

TAKE ACTION: Locate the M on your dial and go for it by setting your camera to manual! No more auto!

The Exposure Triangle and the 3 Elements

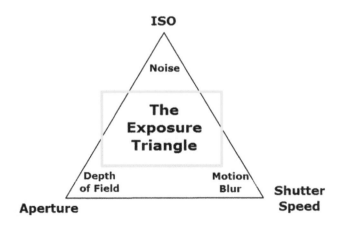

You will notice that the triangle is made up of three elements. Shutter speed, aperture/f-stop, and ISO. They ALL work with light. You will also notice that inside the triangle, each element has another character of the image it controls. This is a key to understanding creative control!

Think of the exposure elements as "the ingredients" to a recipe, just like in cooking. You will need all three ingredients to make your recipe (exposure). As in cooking, you might like more garlic while another does not. As the chef, you decide what works best for you. For instance, your recipe may lean more towards shutter speed instead of aperture.

A change in one of the elements will impact the others. This means that you can never really isolate just one of the elements alone. All three will work together to create the right amount of light exposure on the image sensor. Yet each one has its own unique function. When changing one, you always want to keep in mind that the other two elements will probably need to change as well.

Here is an overview of all three. Now remember, I am about to break each one down into even more bite size pieces for you following the overview.

- **Shutter Speed**

 A *time-value* represented by the amount of TIME the shutter opens and closes to allow light to reach the sensor.

- **Aperture, F-Stop, Iris**

 These three terms all mean the exact same thing. Some photographers prefer one term over the other. The most common are aperture and f-stop. Your aperture/f-stop setting controls how much light comes into the sensor through the opening of the lens as well as depth of field.

- **ISO**

A rating of *sensitivity of light* used to expose the sensor. It is based on film settings.

Remember, in any image, you are using a **combination of ALL three exposure elements**. What combination of the three you choose depends on each situation and the light available. This is a big part of what you will be learning! As an example, you may need a fast shutter speed to stop action. This may require a larger opening of the lens (small number f-stop) to compensate for the lack of time the shutter is allowing light in.

Or, you may want the images to show a lot of depth (sharper from front to back). This requires a larger number f-stop (less light) and that may mean a slower shutter speed to compensate for the light. Now you may need a tripod to achieve the results.

In each of these situations, your ISO setting will be chosen accordingly as well.

These are just two examples of using the manual settings.

Shutter Speed

ISO

Noise

The Exposure Triangle

Depth of Field

Motion Blur

Shutter Speed

Aperture

The shutter speed is a time value you set on your shutter to control light as well as to control movement in your image. The LONGER the shutter speed setting, the MORE light comes into the sensor. Yet motion is not stopped. The FASTER the shutter speed setting, the LESS light comes in but action can be stopped.

Take Action: Find the control for shutter speed. This will be a dial on the front or back of your camera if you own a DSLR. Your camera must be on M for manual. Do not worry YET about making adjustments. Simply locate the dial and understand that you can change your shutter speed with it.

On a Nikon, this will be the dial on the upper right back.

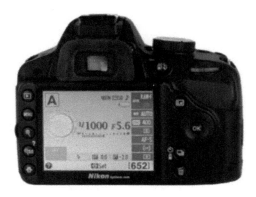

On a Canon, this will be the dial on the upper right front.

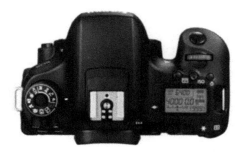

Other systems such as Sony, Pentax, Olympus, Fuji, etc are almost always identical on a DSLR. On smaller cameras, you will need to refer to your camera manual to find out how to change the shutter.

A fast shutter stops action, a slow shutter allows motion.

Shutter Speed Scale

This symbol that looks like a quote denotes you are in seconds

30″ 15″ 10″ 5″ 3″ 1″ 1/2 1/4 1/8 1/15 1/30 1/60 1/125 1/250 1/500 1/1000 1/2000 1/4000

| Slow Shutter slows motion | USE TRIPOD | Fast Shutter stops motion |
| lets MORE light in | under 1/60th | lets LESS light in |

Before we get into the heavy technique side of this, I want to give you a simple method I use to help people understand what a shutter speed is. Think of your shutter this way. A shutter on a house is used to control what? The answer is LIGHT.

Your shutter on your camera does the exact same thing. When you open it, light comes in, and when you close it, light isn't allowed in. The term speed in shutter speed can be thought of like this. The faster you open and close it, the less chance light has to come in. However, the longer you leave it open, the more time there is for light to come in. So from now on, remember this simple analogy and you will always know what shutter speed does!

Simply put, the shutter allows light to come in and expose your sensor or film based on a time value. Based on the time value it is set at, the shutter opens and closes quickly or slowly and allows light onto the sensor. This is why the term speed is used. The shutter also acts as the control to stop or blur motion based on the time value that is being used.

Today's cameras are capable of incredibly fast shutter speeds. It is not uncommon for cameras to go to 1/4000th of a second or even higher, such as 1/8000th of a second. Think about that, 1/8000th of a second! That is fast enough to stop a hummingbird in flight. Yet, a fast shutter speed opens and closes so quickly, very little light is able to come in. We are talking about a fraction of a second! Remember, each element controls light AND another character of the image. For the shutter, that is movement and motion. The shutter speed is going to be what we prioritize when we are photographing any type of movement or action.

You should have taken action and now know where the dial is to change your shutter speed. As you roll the dial left, you will notice that the numbers go from larger to smaller. These numbers are fractions of a second. Some cameras show the numbers as an actual fraction. Others however, show a solid number but it is STILL a fraction of a second. For instance, one camera may show a 2000th of one second as a fraction like this 1/2000 while another camera may simply show it as 2000. They are the same. Now as you scroll the dial left, there comes a point where the fractions turn into seconds and the numbers start to get larger again. This is denoted by a symbol that looks like a quotation mark ". For instance, 15" is a fifteen second exposure and 20" is a twenty second exposure.

Take Action: Use the shutter dial and scroll through the various shutter speeds. When you come to the "bulb" setting, just past 30 seconds, don't worry. I will explain that soon enough.

This image was shot at 1/4000th of a second.

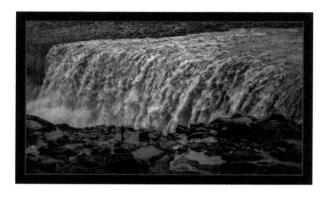

This image was shot at twenty seconds! (20")

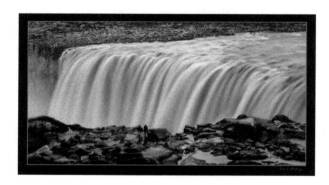

Both images have completely different characteristics based on what I was trying to accomplish with the feel of the water movement. The FAST shutter speed of 1/4000th of a second stopped the water and all of its power. The slow shutter speed of twenty seconds created a beautiful soft flow to the water. Both are correct and both are based on trying to accomplish different feelings in the image of the same subject.

Fast Action

The general rule of thumb is that for action, you should try to go with as fast a shutter speed as you can get away with based on the light in any given situation. If I am photographing wildlife or sports, for example, I generally try to at least get up to 1/1000th of a second or higher to stop the action occurring. Of course, this is all relative. A t-ball game will not require as fast of a shutter speed as a high school game for example.

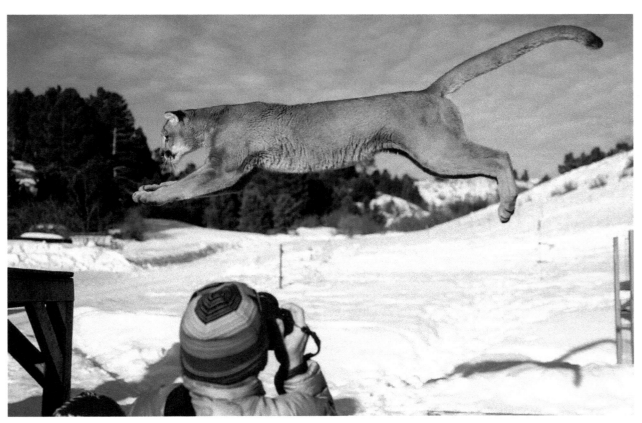

Use a FAST shutter speed such as 1/4000th of a second

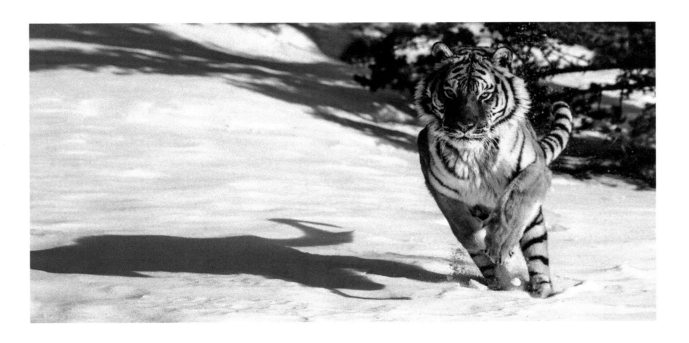

1/4000th of a second

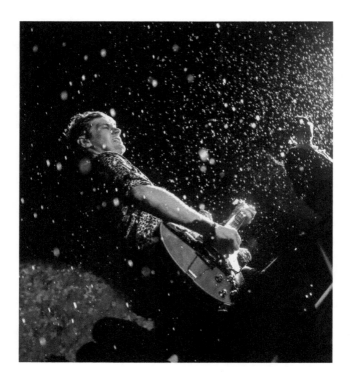

1/800th of a second

So how do you know what shutter speed to use for any given situation? The answer is trial and error. **Remember this; the camera doesn't know either, so auto will do you no good.** The camera will NEVER choose long exposures, for instance, on the water fall.

The idea is that as you learn, you will get better at understanding which shutter speed you will need in certain situations and it will get easier. It is pretty obvious if you are photographing race cars zooming by at 200mph, that you will need a very fast shutter speed. However, for a child playing in the park, maybe only 1/500th of a second is all that is needed.

Every situation is different. One of the beauties of digital photography is that you get instant results to check your work. This is awesome! You know whether you are close or not, right off the bat. So what I recommend doing, is simply choosing a shutter speed you think will work. If your subject is blurry, then make it faster.

1/4000th of a second

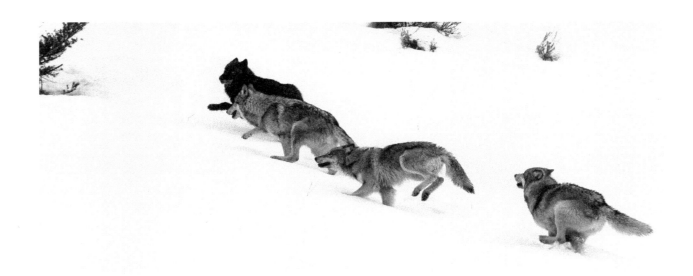

1/2500th of a second

Not fast. Not slow.

The key here is that if you are shooting at anything under 1/60th of a second, you better use a tripod. So my rule of thumb is this. If you are hand-holding, get your shutter speed up. Even if you are photographing a rock! Why if the rocks not moving does it matter? The answer is that, although the rock isn't moving, you may be!

Camera shake has ruined a lot of photographs! A general rule for the minimum shutter speed you should be set at is this: **Whatever focal length your lens is, double it to find the shutter speed to use.**

For example, you can get by with hand-holding at 1/60th of a second if you are using a standard lens. However, the moment you put a large telephoto lens on, such as a 70mm-200mm, now it becomes increasingly difficult to hand-hold without shaking. So in this instance, you would want at least 1/400th of a second shutter speed. You take the lens length of 200mm and double it and set your shutter speed. Of course you can go faster and some people can go slower if they are steady. These are guidelines and, once again, every person and situation is different.

1/160th of a second

1/100th of a second

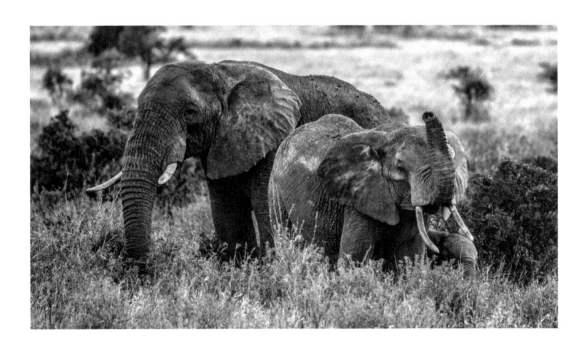

1/400th of a second

Slowing it Down

In learning the manual settings, you are going to gain immense amounts of control over your images. Auto modes NEVER slow down a shutter. You will now be able to slow it down yourself, and get really cool results. The key here is that you MUST use a tripod. Everything MUST remain totally still. Do NOT use a flimsy, off brand, cheap tripod! Your images will only be as good as the tripod that holds things still!

You'll also want to use a cable release so that when the shutter is depressed, you do not shake the camera. If you find yourself without a cable release, simply use the self-timer mode and allow the camera to take a few seconds before firing.

6 seconds (6")

30 seconds (30")

Bulb Setting

Just past the thirty second mark on your camera OR noted by a "B" on your mode dial, you will find the bulb setting. Bulb is a way that you can keep the shutter open for as long as you want. For instance, you can do a four hour exposure of the stars to get star trails. You need a cable release and when you depress the shutter, you lock the release up and can leave it that way as long as you like. With this setting, you can turn night into day! Think about it. A full moon is full of light. It is not a bright as the sun, but it is actually being lit by the sun. You can photograph something that is lit by moonlight over time and accumulate the light on your sensor to get your exposure!

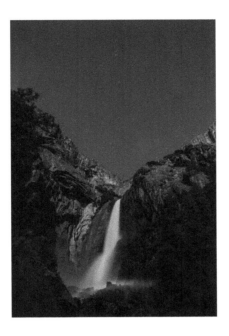

This image of lower Yosemite falls was taken just past midnight on a full moon evening. The falls were lit by moonlight and created the "moonbow" of the mist reflecting in the light. The exposure lasted for thirty seconds and was lit only by the light of the moon!

As you can see from all of the image examples above, it is absolutely awesome to have control! Without it, none of these image examples could be shot. Auto mode would not come close, period.

As we move forward you will understand that just setting the shutter speed is only part of the process. However, I wanted to show you what is possible with just that little amount of control. As we progress, you will be shooting in full manual.

Take Action: Set your camera to the S or Tv (Shutter Priority). Take your ISO and place it on auto. (JUST for now) Refer to your camera menu on how to choose ISO if you have not yet already figured that out. Now experiment with the various shutter speeds and see the results you get. First, try stopping action with various shutter speeds. Then, try really long multi-second exposures with a tripod and see what you can do! You will need the light to be lower, such as during evening or dusk, otherwise a long exposure will be too bright as too much light will be reaching the sensor.

Aperture/F-Stop

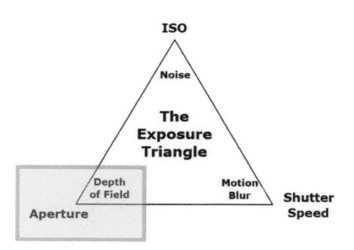

Aperture is the opening of the lens that determines how much light is let in to expose the image sensor. Usually, the more expensive the lens, the larger the aperture opening will be. These are called "fast" lenses because they allow you to obtain a very fast shutter speed as the amount of light needed is being obtained through the aperture opening, which compensates for the fast shutter speed that does not allow much light in.

Many people get confused with the aperture setting because the BIGGER the number, the smaller the opening to let light in, while the SMALLER the number the bigger the opening to let light in!

The SMALLER the f-stop number, the MORE light comes in. The LARGER the f-stop number, the LESS light comes in. A great analogy is to think of the aperture as an eye. After all, that really is what a lens represents. When you are in a dark setting, you may need a bigger opening. This is just like the pupil of your eye, which expands to let more light in. The opposite can be true in a bright setting. Here your pupil would close down to a small opening so not as much light comes in.

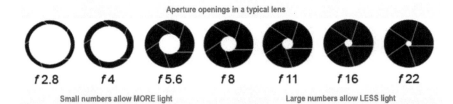

Aperture openings in a typical lens

f 2.8 f 4 f 5.6 f 8 f 11 f 16 f 22

Small numbers allow MORE light Large numbers allow LESS light

Changing your aperture setting can be a bit tricky depending on the camera system. Usually cameras feature a ONE or TWO dial system. See the images below to help with your system.

Nikon users: Nikons, have the dial on the upper back right, as shown. This dial works to change the shutter speed. No matter what Nikon DSLR you own, you should see this dial. Now, look at the front of your camera, by the grip, to see if there is a second dial. This is simply the dial that will change your aperture/f-stop.

If your Nikon has a dial in front like this, this is how you change the aperture/f-stop

If you do NOT see a dial on the front such as the one above, that means your Nikon is a ONE dial system. In this case, the dial that changes your shutter is SHARED by the aperture. To change the aperture, press and HOLD the button on the top that looks like this.

While this button is held down, use the same back dial that changes the shutter speed, and it will now change the aperture.

WARNING: If your camera has the **two dial system**, this button is used for something else as well called exposure compensation. I HIGHLY recommend not depressing that button and using it until you are more familiar with camera settings. For the two dial user, simply use both dials.

Canon users: Canons, all feature the dial on the front right, as shown. This dial works to change the shutter speed. No matter what Canon DSLR you own, you should see this dial. Now, look at the back of your camera. If you see a second dial, this is simply the dial that will change your aperture/f-stop.

If you do NOT see a dial on the back such as above that means your Canon is a ONE dial system. In this case, the dial that changes your shutter is SHARED by the aperture. To change the aperture, press and HOLD the button on the back that looks like this and has an Av next to it.

While this button is held down, use the same dial that changes the shutter speed, and it will now change the aperture.

WARNING: If your camera has the **two dial system**, this button is used for something else called exposure compensation. I HIGHLY recommend not depressing that button and using it until you are more familiar with camera settings. For the two dial user, simply use both dials.

Other systems: Almost all DSLR systems are set up either like a Canon or a Nikon with a one or two dial system. If there is only one dial on your camera, simply look for the plus/minus button. Of course, you can refer to your manual as well.

> **Take Action: Learn how to change your aperture/f-stop. Scroll each way with your aperture and see how the f-stop changes. Your f-stop can ONLY GO AS FAR as the lens allows. A lens that only goes to f4 cannot go to f1.8 for example. It is your lens, NOT your camera that allows your f-stop openings. The more expensive lenses allow more light with f-stop settings such as 2.8 or 1.8 for example.**

Depth of Field

Just like the shutter, the aperture ALSO has two functions, the first being that it, like the shutter, allows light in to expose the image sensor, based on its opening size. The second is depth-of-field.

Depth-of-Field is the range of distance over which objects appear in sharp focus. The lower the number, the LESS depth-of-field and objects will not be as sharp behind or in front of your main subject. More light is also let in through the lens. The HIGHER the number, the MORE depth of field and objects behind or in front of the main subject will be sharper.

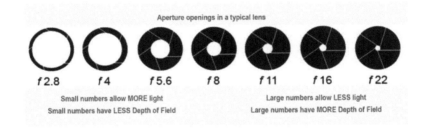

Take a look at these two examples. It's pretty clear why you would want to take control of your depth of field! The first was taken with an f-stop of 1.4 and the next was f22. We gain some pretty awesome control with our aperture!

f1.4

f22

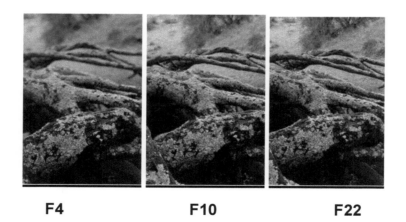

F4 **F10** **F22**

Take Action: Set your camera to the A or Av (Aperture Priority). Take your ISO and place it on auto (JUST for now). Refer to your camera menu on how to choose ISO if you haven't already figured that out. Now experiment with the various aperture/f-stop settings and see the results you get. First, focus on something close and use a small number f-stop. Then change the f-stop to a big number like f22 and see what a difference this makes!

Remember this—Little number equals little Depth and Big number equals Big Depth.

Depth is also relative to how close you are to your subject AND how far away your subject is from the background. In other words, you can also increase depth by bringing your subject out away from the background.

F8 is Great Rule!

Since depth is also relative to how close you are to a subject, sometimes we do not need to set the aperture for shallow or deep depth of field. The majority of lenses on the market set f5.6 – f8 as the sharpest part of the lens. Do not confuse the sharpest part of the lens with actual depth. Since a lens that is a zoom lens has various moving parts and focal lengths, lenses are usually at their "sweet" spot at around f8. The reason this is important is that if you are photographing a scene for example, and that scene is far out in the distance, then in this situation depth is really not an issue no matter what f-stop you use. In this case, you might as well use the sweet spot of the lens. Typically, 80%-90% of scenic images are going to be great at F8. Remember this: F8 is great!

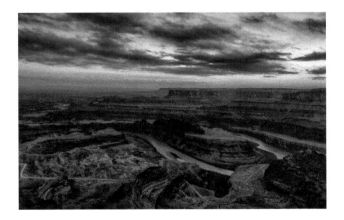

This image above was shot at f8. Even though there is a lot of foreground to background in this image, due to my distance to the subject matter, I could have shot this on any f-stop and depth of field would not have been affected. In a case like this, I will use f8, the "sweet spot" of the lens.

Shot at f22-Depth mattered, due to my relationship to the subject and the foreground to background composition.

ISO

The measure of a digital camera sensor's sensitivity to light

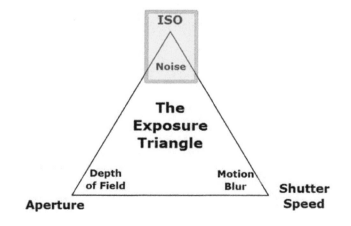

If you've ever purchased film, you have experienced this number. With film, you had to choose what "speed" of film you wanted such as 100, 200, 400, 1000, etc. You also had to use the whole roll and hope you chose what would work out best for your given situation based on the light you thought you might have available. One of the beautiful benefits of digital cameras is the ability to change the ISO from image to image. This gives you one more step in the exposure process, but MUCH greater control in any situation you are photographing.

The general rule of thumb is that you want to try to use the LOWEST possible ISO you can at any given time. The reason is, the lower the number, the better the quality of the image. The higher the ISO setting, the more "noise" (a "grainy texture") you will see in the image which is a lesser quality exposure. I usually start here in our exposure process. I choose what I think is going to be the ISO that I can get by with and then work with the other two elements of shutter speed and aperture to get my exposure. If I cannot obtain what I need, I can then increase the ISO.

ISO SCALE

| 50 | 100 | 200 | 400 | 1600 | 3200 | 6400 |

Less Sensitive to Light
More Light Needed
Less Image Noise/Grain

More Sensitive to Light
Less Light Needed
More Image Noise/Grain

The more light that is available, the LOWER the number you need. Typically, on a bright sunny day you can use 100 or 200 ISO and still get plenty of light for your other settings of shutter speed and aperture. The darker the circumstances, the higher the ISO needs to be, but this results in a loss of quality. However, we can still use lower ISOs IF we accumulate light over a long period of exposure.

When you're working in low light situations and you're working with action, you may find that you need to increase the ISO to a higher degree to capture the action because your shutter speed is moving so quickly and therefore you need to make your ISO more sensitive to light

Think about ISO like this—In film, we had a piece of plastic and that piece of plastic had a silver coating on it. That silver coating was our sensitivity to light. For example, in ISO 100 or ISO 200, there was a lot of silver that was placed on that plastic.

Therefore, it took a lot of light to expose and create that image due to the thickness of silver. We either got enough light by it being bright enough, or doing a long exposure and accumulating the light. A flash also helps with bringing in light.

The thickness of the silver that was put on the plastic determined the quality, as the entire piece of plastic was covered. As you got to higher and higher ISO numbers, less silver was used on the plastic film. What that meant was that you didn't need to have as much light to create the exposure because the silver wasn't as thick.

In the film days, we got up to ISO ratings of around 3200 at the highest end. It was great because you could shoot in situations with lower light, OR you could also shoot action (fast shutter, less light) and it would help as you didn't need as much light. The problem is that you would see what's known as grain. Grain is where the light particles were not being recorded because there was no silver to record it. They're the parts where no light was exposed to the film.

This translates to a sensor like this—When a sensor is set on an ISO setting of 100 or 200 for example, all of the micro lenses that record light are on. It takes a lot of light to fill up all of those micro lenses and make the image.

Just like film, we can get that light a number of ways. There are times when we are aiming for a fast shutter speed to capture action, we are in low light, and even with a lens that lets a lot of light in, we can't get the image we need. It is here in these instances that we can use a higher ISO. We will lose quality, just like in film, because in a higher ISO not as many micro lenses are recording the light, but in doing so, there are gaps where nothing was recorded. In today's digital world, this is known as digital noise.

Shot with 100 ISO. A beautiful full bright day and the image has no "noise."

This image above was shot in EXTREMELY low light. Yet it was action so a fast shutter speed was needed during this rock show. With today's technology, I was able to use an ISO of 16,000 which enabled me to use a fast shutter speed of 1/1000th of a second to get this shot. This would have been impossible in film. However, you can really see the "noise" in the image. Yet, I got an image! NEVER let your photograph suffer due to using a slower shutter speed and a lower ISO. A blurred image is far worse than a "noisy" one.

This image was shot at 2500 ISO. It has some "noise" but not as much as the other where an extreme ISO was needed. More light allowed for less ISO to be used resulting in less image "noise".

Common ISO Settings

ISO 100 (some Nikon 200)—Best quality for good bright situations such as outdoors on a sunny day or with flash (adding light).

ISO 400—Good all around. Indoors with available window light, fast moving sports, overcast days.

ISO 800—Lower light situations, mostly indoor and at dusk.

ISO 1600—Very low light such as candle light, fireplace, theatre, concerts. Lowest quality.

LOWER ISO such as ISO 100 or 200

- BETTER quality

- LESS noise

- MORE light is needed for good exposure.

HIGHER ISO such as ISO 1000 and higher

- LOWER quality

- MORE noise

- LESS light is needed for a good exposure.

Significant quality loss above ISO 1600 does start to happen. However, as cameras have continued to get better, 1600 on a new camera is FAR better quality than just a few years ago and most new cameras hold up just fine in this area. As you start going higher and higher though, you will see significant "noise" in your images. That is fine if you need it to get a shot, but do not just use that without paying attention. Many of today's cameras are now offering ISO ranges of up to 25,000 and above! The quality is not very good, but the way technology continues to grow, I would not be surprised to see ISO ranges that high that look just fine in a few short years.

Take Action: Go back to your ISO settings and take it off auto. Scroll through the various ISO settings and see the range that is available on your camera. As we get into full manual settings, you will be adjusting your ISO as well. If you are struggling, it is OK to use auto ISO as you learn. However, eventually, you will want to control this element as well.

Light Meter

At this point, you now have a basic understanding of all three of the exposure elements. Give yourself a pat on the back! Most people with great cameras never get this far and you have! You already know how to shoot with a faster shutter speed and control the action with shutter priority mode. You also know the same about depth of field with the aperture priority mode. Those two items alone provide you with far more control than auto or scene modes and from here on out, the very least you should be using is one of those. If you get frustrated and are having a difficult time, you can always resort to one of those modes if need be. Again, having some control is way better than no control!

Now we are going to move forward into the most creative control aspects of your camera. Are you ready? I am going to take you into full manual and it is going to be awesome!

The key to using all three elements and knowing that you have the right amount of light for the exposure will be based on your light meter.

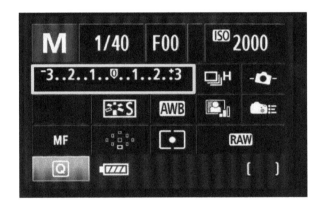

Take Action: Look at the back of your LCD AND inside your viewfinder. Find the scale that looks similar to this. This is your light meter.

A light meter is an instrument or display inside your camera viewfinder and on your LCD read out that tells you if the amount of light reaching the sensor is correct for your exposure. The light meter takes into account all three exposure elements, shutter speed, ISO, and aperture settings. Usually, DSLR cameras feature the light meter display on the bottom, when you look through the eye piece. They also tend to display simultaneously on the top digital display or LCD screen.

Unless you are using a tripod, I recommend using the one INSIDE your viewfinder as you are looking through your camera so that you can adjust while your subject is in the viewfinder and you

are consistent with where the camera is reading the light from. Otherwise, the camera may take a reading of something different while you are looking at the top or LCD screen.

The idea here is to get all three elements working together to allow the correct amount of light to expose the sensor. Each element can give you a different result based on what you are looking for such as stopped action in the case of a race car, or shallow depth-of-field in the case of a flower. When you adjust one, you must adjust another to CONTROL the amount of light that the image sensor is exposed to. Too much light and the image will be over-exposed and bright. If there is not enough light, the image will be dark and under-exposed.

Using your camera light meter will help you to know when the adjustments for the exposure are correct.

Even when shooting on auto mode, the camera still uses the three elements. However, the big difference is that you are now taking control and in doing so; you control ALL of the aspects of your image. Not just light, but movement and depth too! This is so important because, as stated earlier, the camera does not know what your subject is. You do!

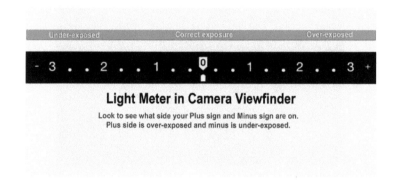

Light Meter in Camera Viewfinder
Look to see what side your Plus sign and Minus sign are on.
Plus side is over-exposed and minus is under-exposed.

In the above image, the light meter scale is set in the middle to zero showing us we obtained the proper exposure. If it was to the minus side, it would mean we were under exposed. If it was on the positive side, that would mean we were over exposed. Sometimes you may find you prefer to underexpose OR overexpose a picture to get the results you want. Remember, YOU are in control!

You may see your meter with an arrow or a blinking line to the far right or left. This simply means you are WAY off the scale and not on the readable area yet. As you move your exposure through one of the three elements, to either add or take away light based on whether you are overexposed or underexposed, it may take a bit of movement before you actually see the line moving on the scale. This is because you are so far down the scale that you may be way beyond just a few notches. Just keep adjusting to allow more or less light in, depending on the position of the arrow or the blinking line and eventually the needle will go solid and then start moving into position.

Take Action: Make sure you are on full manual (M on the dial) and make sure your ISO is set to 100 or 400. Set your aperture to its smallest number (largest opening). Now look through the viewfinder at your light meter. If you are on the positive or plus side, you have too much light. Take your shutter speed and reduce the light by moving your dial to the right, which makes the shutter faster (reducing light through time value).

If you are on the negative or minus side, you have too little light. Take your shutter speed and allow more light by moving your dial to the left, which is makes the shutter slower (allowing more light through time value).

Do these steps until you see the light meter line up in the center of the scale. CONGRATULATIONS, you have just created your first FULL MANUAL exposure.

Bringing It All Together

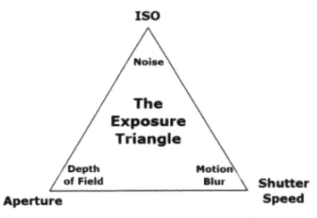

Using ALL 3 to get our desired results!

Now that I know what ISO, shutter speed, and an f-stop are, what do I choose first and why?

As we venture into full manual, I want you to get this one question in your head and ALWAYS refer to it. The question to ask yourself before any shoot is this. Is action or depth my priority? The answer to this question will help you prioritize what settings to start with each and every time!

Here is a step by step process. This will get you working in full manual and you will soon be enjoying full creative control!

Steps to Exposure

Step 1: Choose your ISO.

As a basic rule of thumb, the first element to start with is the ISO. Always try to choose the lowest possible ISO that you can. We usually start with a 100 or 200 ISO and go from there. If we find that this is not a high enough ISO for the light available in the situation, we can always adjust (unlike the old days with film). The idea is to start with the best quality image we can get without any image "noise". Then, we adjust if we need to. I usually recommend starting at the lowest ISO I think will work, and then just leaving it alone for a bit. We can always re-adjust.

- Bright Sun or Flash—100 or 200

- Light Shade/Cloudy/Window Light—400

- Dark Shade/Heavy Overcast—800

- Dusk/Indoor/ Lower light—1600 (unless doing long exposures accumulating light)

Many cameras go beyond 1600 ISO. You start to lose significant quality in the image after this point, unless you have very high-end camera.

Step 2: Ask yourself this question: Is action or depth my priority?

Based on the answer to this question, you will know which setting you should adjust next for your exposure. For example, if you are photographing a fast-moving race car, the answer would be action. You now know that shutter speed is what controls action as well as light. In this case, you would start by adjusting your shutter speed first. Then we simply move the aperture into place to line up our light meter.

When considering what shutter speed to use in a photograph, you should always ask yourself whether anything in your scene is moving and how you'd like to capture that movement. Would you prefer it to be completely stopped? Maybe you want to have a sense of motion and movement? If there is movement in your scene, then you have the choice of either freezing the movement or allowing it to have some motion blur.

If depth of field is your priority, then you would start with the aperture setting you want and simply adjust your shutter speed to line up the meter. Remember these hints.

Big number = Big depth

Little number = Little depth

F8 is great rule (good for 80% of most scenes and the sweet spot of most lenses)

Step 3: Change the ISO if you can't get what you need out of the aperture or shutter speed.

If, as an example, you want or need a very fast shutter speed to stop action and, even though you opened your aperture as far as the lens would go (the smallest number), there just isn't enough light to allow a fast shutter speed, you can go back to the ISO and increase it so it is more sensitive to the light on hand.

Even in some outdoor situations where there is a lot of light, very little light is able to hit the sensor during an extremely fast shutter speed. This would happen if the shutter is opening and closing at a high rate such as $1/2000^{th}$ of a second or above, for example. Even with your aperture open, it may not be enough. In this case, simply increase your ISO to get what you need. Do NOT settle for a blurry picture because you're worried about ISO quality. Remember, you can always go to auto ISO if you are struggling here.

Now let's say you want a really deep depth of field. You set your lens aperture to the largest number (smallest opening) it will go. Now you set the shutter speed and line up the light meter for the proper exposure. Yet you find that the shutter is really too slow to hand-hold. (1/60th of a second or less) Again, you can take the ISO and increase it so that not as much light is needed for the exposure, which would then allow you to get your shutter speed higher for hand-holding. Remember, even if it is a natural scene and nothing is moving, your ability to hand-hold at slow shutter speeds is very limited. This is why landscape photographers use tripods. They want to shoot at low ISO for quality, big depth for some scenes, and not worry about camera shake if they find their shutter speed falling too slow.

Once again, the higher the ISO, the less light is needed to expose the sensor. The trade-off is that you sacrifice quality. In today's digital cameras, an ISO of up to 800 gives you good results with very few issues. Above that, you really start to see the noise. The larger the images you print, the more noise will be visible. If the image is just going to be small or online, noise is not as much of a factor to be concerned about. I have no issue shooting up to 800 ISO at all.

Many times, people forget that they can adjust their ISO up or down once they have no more options when it comes to controlling the other two elements. Exposure ALWAYS comes down to the three elements of ISO, shutter speed and aperture. Always choose your ISO and then either your shutter or aperture and then adjust accordingly. This is how to get your exposures. This does take practice, but you will enjoy having the creative control you need in order to get the amazing images you know you can take!

Take Action: At this point, you have learned a TON. It's time to have some fun!! Before proceeding into the next chapters, take some time and go out and photograph! Start with something simple and play with all of the settings. Work lining up your light meter. Start with working the shutter speed and adjusting the aperture to line it up.

Remember, if you do not have enough light, increase your ISO. Then set your aperture first and adjust your shutter speed to line up the meter. The same thing applies with ISO. If you find you can't get enough, bump the ISO up.

If you are struggling, feel free to set your ISO to auto to help.

Histograms

Have you ever taken a photograph and when you got it home and downloaded it to your computer; you noticed it didn't look ANYTHING like the back of your LCD on your camera? This is a common occurrence and there are a variety of reasons that explain how this can happen.

This is a VERY important part of your camera system and one you need to pay VERY close attention to while photographing. When I am photographing, I rely on my histogram ALL the time. I do NOT rely on the LCD screen as it can be very inaccurate and also hard to see in certain situations such as on a bright day.

The histogram is an essential tool in digital photography, but many people don't know what it is or do not understand its use. Its purpose is to evaluate whether the exposure is correct and it is an excellent tool when it comes to understanding your exposure. It allows us to know whether we've lost detail in the areas with shadows or highlights.

The histogram is a graph that shows the brightness distribution of an image, with pure black on one end, pure white on the other, and grey in the middle. Because measuring light is what photography is all about, the histogram works pretty well in a digital camera, but it also may be a little confusing. However, understanding its use is essential in capturing excellent exposures!

The histogram is a true representation of pixels recorded in an image.

All histograms will look different based on the image taken.

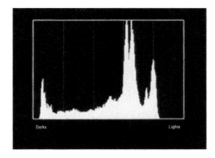

Your histogram can be found by changing your LCD screen settings to look like this image above. Use your camera manual and look under histogram if you cannot seem to locate a screen that looks like this. Usually it can be found by pressing the info button on Canon or pressing up on the Nikons back button system. The histogram is the graph that looks like "mountains". You may see two histograms, including one that has red, green and blue lines. For exposure purposes, use the grey scale one.

The MOST important part of the histogram is to make sure that you are not clipping all the way to the far right if you have whites. This would mean that there are no details and the image has over-exposure in this area.

You MUST understand that images can look good on your LCD and yet NOT have the correct exposure. In ALL of the examples below, anyone of these could have looked good on an LCD, based on many factors such as the LCD brightness settings and the environment in which the LCD is being viewed!

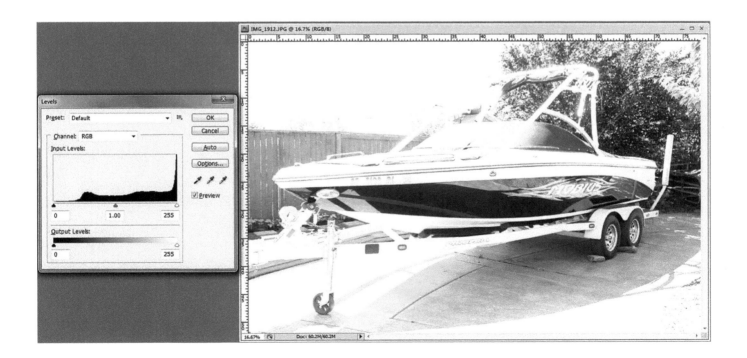

This image above shows that there is no detail in the highlights. Look at how the histogram is represented. This image would also show "blinking" black areas in the highlights, indicating that no pixels were recorded and that those areas are over exposed.

Now the image is under exposed. We have details in the highlights, but the shadows are under exposed as represented by the graph.

This is the correct exposure for this image. There is one little clipping to the right which is the highlight on the chrome. In some images, it is impossible due to the lighting conditions to get ALL tones exposed correctly. Notice that the "mountains" of the histogram are not set in the middle. This is because this image is primarily made of blacks and whites with very few mid tones.

If you are in a situation where the lighting is not even and you have to choose whether to over-expose or under-expose the rule is that it is BETTER to slightly under-expose. It is impossible to pull details out of images where there are no pixels recorded. However, in an under-exposed image, at least pixels are recorded and you can use editing software to pull the details out.

The rule is to error on the UNDEREXPOSED side in digital photography

> **Take Action: Locate the histogram display within your camera. You will most likely need to use your camera manual to do so. For Canon, use the info button and as you continually depress it; it will scroll through the options. For Nikon and most other brands, USUALLY it is by depressing upwards on the keypad on back of camera. Use your manual for your specific camera model.**

Lenses

Besides your initial investment with the camera you purchase, your lens purchases will be equal to and possibly of greater value to you in both utility and the amount of dollars invested. You may change cameras every few years, but your lenses, as long as they fit the same system make of your camera, will be around for you to use for years and years.

Most people receive their camera with a basic lens. It quickly becomes apparent that this lens may work for some things, but not for other things. Once you learn which kinds of lenses work best for which kinds of applications, you'll likely want to begin making your own "wish list" of the type of lenses you will want to purchase in the future.

Typically, the lens that arrives with your camera purchase is a very basic lens of less-than-adequate or even, poor quality. As you grow in your ability as a photographer, lens choices will be the item you will want to invest in more than anything else.

Various Lenses

Glass lenses will offer you a much higher quality and are worth the investment of more money. The larger the aperture opening of a lens, the more expensive it will generally be. Some people really need a lens that will help them in low light situations. That small number aperture means more light. More light means a higher cost and better glass. Others may not have that need. It is important to understand your needs and what you want to accomplish before purchasing lenses.

- Lenses represent as much of an investment if not more than your camera.

- No matter how good your camera, if the lens quality is poor, it will reflect in your images!

- Create a lens "Wish List"

There are a wide variety of lenses available and price ranges as well. There are SEVERAL factors that should help you determine what lenses to purchase!

- Quality

- Manufacturer

- Price range

- Aperture range

- Focal lengths

- Consumer reviews

- Your subject matter

Fixed Lenses vs Zoom

Fixed lenses are lenses that have no zoom capability. You can purchase a lens such as a 50mm or a 28mm, for example. They are set in their focal length.

For most amateurs, this is not the way to go unless you have a very SPECIFIC reason to buy such a lens. The drawback is this, although great in quality, you have to purchase several lenses to have different focal lengths available. This means you have to carry much more equipment and also change your lenses much more frequently while photographing. While these lenses are typically of a better quality, the drawbacks usually outweigh the quality differences for most photographers, especially amateurs and hobbyists. With that said, below I will recommend an inexpensive fixed lens that is a great addition to have in your camera bag!

- Fixed lenses are lenses that have NO zoom capability.

- A lens has a SET focal length and cannot be changed. These lenses are usually very good and very expensive.

- You have to buy SEVERAL lenses to have many focal lengths.

What's in Our Bag?

Before I show you what is in our bag, please remember this—We are full time professional photographers. Our work is produced on a very large scale and can sell for thousands of dollars. With this in mind, we have some amazing lenses and you may or may not want to spend that kind of money on them. However, everyone always likes to know what we own and why. In sharing this with you, please do not feel you have to run out and purchase the latest and greatest. If you are serious about photography, no doubt you will want to invest in great lenses. At the same time, understand that for many of you, there is a variety of options to allow you to enjoy photography as much as you like without such expensive gear.

The McKay's Bag

- Wide Angle

 (10-24mm) or Canon L series (16-35mm) f2.8

- Canon L series Medium or Overall lens (24-105mm) f4

- Canon L series Telephoto (70-200mm) f2.8

- Canon 85mm prime/fixed f1.2

- Tamron Super Telephoto (150mm-600mm) f4-5.6

Most lens manufacturers have the following lens focal lengths available in a variety of models. You will notice that there is usually an overlap of focal length when working with zoom lenses.

For the most part, you will notice that I use "L" series lenses. As I am a Canon shooter, the L series is the top of the line for Canon. Again, my wife and I are full-time pros and the best lenses matter. In fact, our lenses can cost as much as, if not more than, the camera it is attached to! I do have one "after-market brand" lens. That is the Tamron Super Telephoto. I will talk about this shortly and explain why I specifically chose it.

If you have been lens shopping, you may have noticed there are many "all in one" lenses. This would be a lens such as the Tamron 18mm-300mm. This can be a great way to keep only one lens on at all times. You never have to bother with changing lenses, and it is much easier to travel with. The quality can be just fine for many photography enthusiasts.

The downside is that these lenses are not available with a very fast aperture opening such as 2.8 and most come starting in the f3.5-f5.6 range which limits you in lower light situations. These lenses may not be as sharp either. But for most, you may never see the difference if you are not printing your images above an 11x14, for example. So for many, this type of lens is an excellent way to go. Tamron and Sigma make excellent choices for aftermarket lenses that are very consistent in quality.

For the serious amateur or the person considering a career, we would recommend saving your money, creating your wish list, and buying as many different lenses as you can afford that have faster aperture openings (such as f2.8). It really comes down to your needs and, of course….your budget!

After-Market Brands

Tamron, Sigma and Tokina are all excellent aftermarket lens manufacturers. They all tend to make consistently very good lenses and you can save several hundreds of dollars choosing a lens from one of these manufacturers' vs the name brand. In some cases, the quality is better and at a reduced rate. This is where you should do research before making a purchase. You can also rent and try lenses first. There are several companies that allow you to do this.

Research

Our good friends Toby and Christina at Photorec.tv are awesome people who test and review TONS of gear. I HIGHLY recommend you check out their web site www.photorec.tv and subscribe to their YouTube site https://www.youtube.com/user/camerarecToby

They are a wealth of information and I trust their reviews. In fact, Toby and Christina now travel with us as instructors and vloggers on many of our photography tours.

www.photorec.tv

Crop Factor

The first thing to understand in choosing the focal length of your lens is that not all lenses act exactly the same on each camera. In the image below, notice that the sensor is smaller in the camera on the right. Camera manufacturers make great sensors these days at amazing prices. In fact, technology that just ten years ago, was either non-existent or cost upwards of $25,000 is now in your $500 camera! In order to get you, the consumer, high quality, but at a more affordable price, one of the things manufacturers do is to make the sensor smaller. This is still a great quality camera, it's just as not of as high a quality as a "full frame" sensor camera (the camera on the left). You will notice that the smaller sensor does not reach all the way to the edge like the larger sensor does. What this means is that when you attach the same lens to either camera, the camera does not see through that lens in the same way. In the full frame sensor camera, you will see more of the scene than in the smaller sensor.

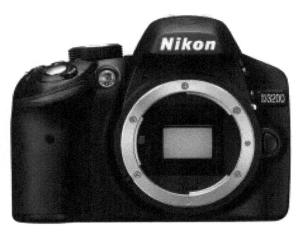

Most medium priced consumer cameras are not full frame.

With this in mind, when shopping for a lens, you need to consider what you want to accomplish with your photography. For instance, I love to shoot with wide angle lenses. My camera is a full frame sensor camera. If I attach a 16mm-35mm wide angle lens to my camera, I see the full scene. However, if I then take and attach the exact same lens to a smaller sensor camera, I will not see the same scene. In order to take care of this, lens manufacturers simply made lenses that will see the same, but to do so, you have to choose a different lens.

For example, on a crop sensor camera, you would need a 10mm lens to see the exact same thing that I see on my camera with a 16mm lens. If you look at the scale below, you can see how this is determined. For Canon, the factor is 1.6. For Nikon and most other manufactures, it is 1.5. You simply take the lens focal length as written on the lens, multiply by the crop factor, and you get what that lens is ACTUALLY producing for you.

Overview of lenses and crop factor. (1.6 for Canon)

10-24mm = 16-38.4 mm

16-35mm = 25.6-56mm

24-105mm = 38.4-168mm

70-210mm = 112-336mm

*50mm = 80mm (Perfect prime lens for low light and portraits)

If you hate math, like I do, and this is all a bit confusing, do not worry; you are not alone! If you have a smaller sensor camera and don't want to mess with the math, just remember this—for a wide angle, rather than purchase a 16mm or 17mm on the wide end, look for a 10mm or 11mm. That will get you the width you want!

Below are some of the popular cameras and the categories they fall into. Most people who have a full frame sensor camera know this because they bought their system with that in mind. If you purchased a fairly inexpensive camera kit, chances are, it is not full frame.

Some Full Frame Cameras

Canon Mk 2 and 3

Canon 6d

Nikon D810

Sony A7 R2

Non full frame series Cameras

Canon Rebel/ T Series

Nikon D3100-7100 series

What Do Lenses See?

Each lens has a specific function and you will find that there is no perfect lens. Sure you can purchase a good all-around lens such as an 18mm-300mm all in one type lens. Yet even that will not get you real wide angle images. Let's take a look at some examples of lenses, what they do and how they "see".

Wide angle

- Great for tight corners in rooms.

- Wide scenery.

- NOT GOOD for portraits.

- Perspective is skewed.

Wide angle lenses are some of my favorites. I love using a wide angle lens not only to see more, but to help take my viewer on a journey through the image. The idea is that rather than focusing in tight on the subject, I will allow my viewer to "step into" my image with their eyes, and go through to the main subject.

See image taken below!

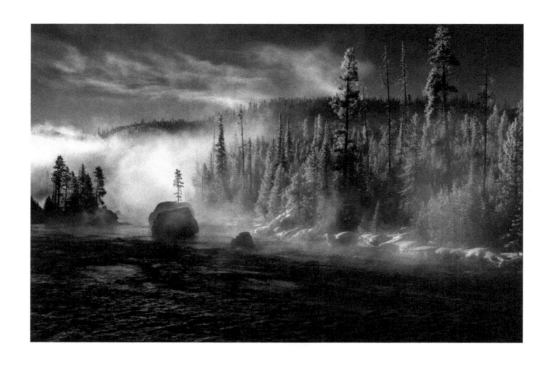

Shot at focal length of 16mm.

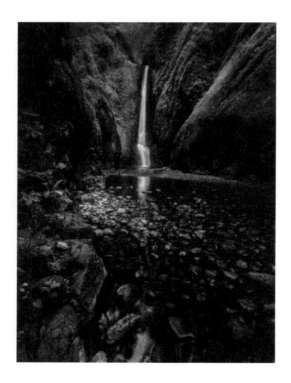

By tilting the camera down right at where my feet were, the viewer can "walk into" the photograph and take a journey to the waterfall.

All images below shot at Focal length of 16mm

The wide angle allowed for so much more perspective.

A medium range zoom lens

- Good all around

- Perspective not skewed

- Good for basic portraits and groups

A medium all around lens is my go to "walk around lens" a lot of the time. If I do not feel like carrying a lot of gear, I will use this lens and carry my wide angle as well. Both of these images were taken with a medium range lens.

Shot at Focal length of 105mm

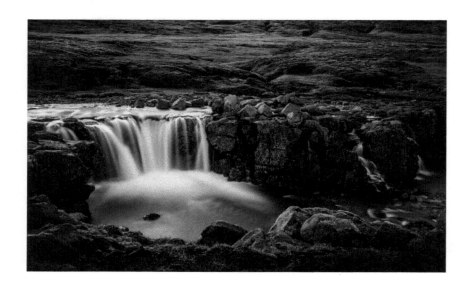

Shot at Focal length of 85mm

A long telephoto zoom lens

- Good for sports and events

- Good for individual portraits

- Used anytime you want to get closer to your subject from a distance.

A good, longer telephoto is a must for the person photographing sporting events. A lens with an aperture of f2.8 will be what you need for low light action. This lens allows you to get in fairly close to the action. This lens is also great for individual portraits. The reason is that just as wide angle

skews perspective and can make people look heavier, a longer lens zoomed in on your subject tends to be much more flattering!

Nick Sharples

Both images shot at focal length of 200mm

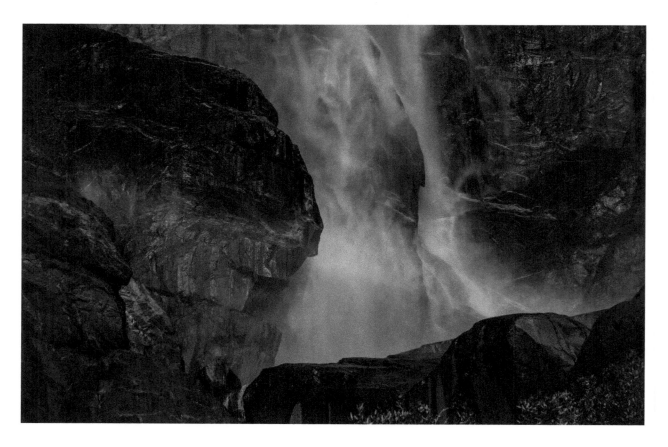

A super long telephoto zoom lens

- Good for sports and wildlife

- Used anytime you want to get closer to your subject from a distance.

I personally have a super long telephoto lens made by Tamron. These lenses can get extremely expensive (up to several thousands of dollars). For example, the Canon 400mm f2.8 weighs 35lbs and is $11,000! YES, it is an amazing lens! For most people though, it is more lens than they need. I have friends who are professional sports photographers for NFL teams and other major events. They need a long lens that also lets in a lot of light. They are shooting extremely fast sports in low light situations. Therefore, they need to get their shutter speeds up and do not want to increase their ISO too much so that they can preserve quality. Plus, these lenses are extremely sharp.

However, if you are looking for a very good super long lens at a great price, I have found both the Tamron and the Sigma 150mm-600mm lenses to be very good. They are priced right at $1000! Yes, $1000, NOT $11,000. I have used my lens several times as well as for thirty-two days straight photographing wildlife in Tanzania. I have to admit, I was very cautious in the beginning in regards to how well this new breed of lens would perform. It passed with flying colors. The down side is that the aperture range at f4-f5.6 does not allow a ton of light in. But, at 4lbs, it's a lot easier to handle and travel with as well.

Alex using my 150-600mm lens in Yellowstone!

Shot at 600mm AND cropped in even tighter. I am very happy with the results and have this as 30 x 30 inch image in our gallery. It is very sharp.

These images were both taken at the 600mm distance.

Judge for yourself if you think they are sharp.

Macro lens

- Used for extreme close up photography

If you love to shoot flowers, insects and anything else extremely close up, then this is the lens for you. Do some research and find what fits your budget and read reviews. I am not a person who shoots a lot of macro photography. Patience is a must for this type of photography and I applaud the photographers who do it well as it is not easy.

A water drop photographed by Ally McKay.

If you look closely, you can see the sunrise over Yosemite Falls through the drop!

Fish eye specialty lens

- Used for ultra-wide images. Can look like a fish eye, hence the name.

In this image, I was only about four feet from everyone, yet I was able to get everyone in one shot even though they were spread out over about twenty feet! Notice how the perspective is skewing? That is a result of the ultra-wide angle glass used.

TAKE ACTION: Go out and shoot with all of the lenses you have. Experiment with the various focal lengths and see what you enjoy.

Composition

My wife and I have had the opportunity to work with many great photographers throughout the years. Without a doubt, the ones that we both enjoy the most, as far as their work goes, are the ones who have amazing composition. Many people can learn the technique side of photography. That is something that you need for sure; however, a great technically proficient image that lacks in composition will not move the viewer emotionally. The goal in creating amazing photographs is not to just get the elements of exposure correct, it is to also get great composition and to make an impact with your images. We have learned that we can have twenty students on a photography tour and line them up. They will all be nailing their exposure. What makes the difference in whether their photography is going to be amazing or not is composition.

In fact, if all you ever did was shoot pictures on your phone, composition is the one thing that will set your images apart from everyone else! That is how important it is!

"Most amateur photographers fail first by NOT changing their position!"

Move Your Feet!

One of the first things I like to teach our students when we are out on a photography tour is to move their feet and change position. I want you to get out of what I call the "tour bus" mentality. That is, you get on a tour bus, you get off, and you stand there next to everyone else, and shoot your picture. People can't see the same Yosemite Ansel Adams spent a lifetime photographing in just three hours! Take time, look around, enjoy the moment, and THEN photograph!

Below is Ally's shot she was taking from the above image. If she had stood up tour bus style she would have never gotten this. Sometimes, you have to lie down and do what it takes to get the shot!

When moving your feet, always look beyond your subject. Make sure nothing is distracting from your main subject. I will shoot the same subject from a variety of angles. My own personal rule is that if something has grabbed my interest to photograph, I should explore it a bit before giving up on the shot. Therefore, I will shoot the same subject in a variety of ways looking for the best of the best in an image.

360 Degree Rule

During my career, there have been tons of times where I became fixated on a subject, only to turn around and realize that there was a great shot behind me that I was missing. I have trained myself to always do 360 degree turns when shooting. More often than not, there is another shot waiting to be taken right behind you!

Rule of Thirds

The rule of thirds is one of the most basic composition guidelines in photography. The rule explains what part of an image the human eye is most strongly drawn to by breaking the image into nine equal squares.

The four points where these lines intersect are the strongest focal points.

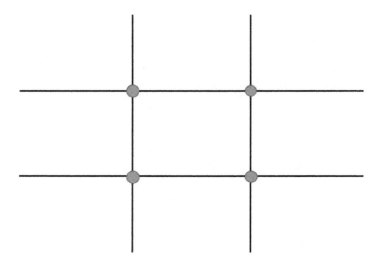

Notice the placement of the subjects in these images. Be sure to give space to the side of the image you want the viewer to lead into. In this way, the viewer does not move out of the image.

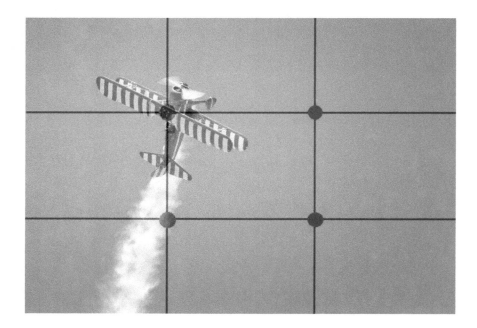

Notice in this image of an oak tree that not only is the tree on the right third of the image, within the power point, but the horizon line is also on the lower third. It is very common for new photographers to use the middle of the frame for horizon lines in landscape photographs. Be sure to use the upper or lower third and not place horizon lines directly in the middle.

Space

If subjects are moving or pointing to a side, use the rule of thirds to allow a subject space to move into. This allows the viewer to not feel tense when looking at the image. Give space to the side the subject is pointing towards.

Ally McKay

Leading Lines

Leading lines are a compositional tool to draw a viewer into and through a photograph. Use leading lines to create much more interest in your subject by leading the viewer into it.

Anything with a definite line can be a leading line. Fences, roads, paths, railroad tracks, and even a shoreline can lead the eye. If you can pair leading lines with a subject that is placed according to the rule of thirds your image should be very strong.

Ally McKay

In the western culture, we read from left to right. For that reason, we tend to find lines that lead us from left to right are stronger. Notice how, in these images of Ally's, everything leads you from left to right through the images and end on the lower third power point. That makes for incredibly strong composition.

Ally McKay

Curves

Curves are graceful, dynamic and add visual movement to an image. They can separate or connect elements or simply offer a balance. Curves can help to take the viewer on a visual journey through the image.

In this image, I had to move my feet and walk down the road in order to find a location where the river came from left to right and curved back into the scene without getting cut off. Sometimes you have to work a bit to get the image. But it is worth it!

Ally McKay

In this image of Ally's, notice the curves she used. Some might think this was all just chance to get this shot the way it is. The reality is, Ally waited for a crowd that was photographing the ruins to leave, made sure the image came from left to right as a leading line, used the curve of the hedge, made sure the rule of thirds was used and placed her horizon on the lower third in order for the amazing sky to be seen! Composition is the key to amazing photographs.

Natural Framing

The natural framing of an image is an excellent way to give a different perspective. By using natural frames, it's as if we can allow the viewer to see into another world. It is also a great way to direct your viewer toward a specific subject, as seen below. When out photographing, look for what others are missing. In this first image, tourist just kept walking by the beautiful frame of the window out into the harbor in Vernazza Italy.

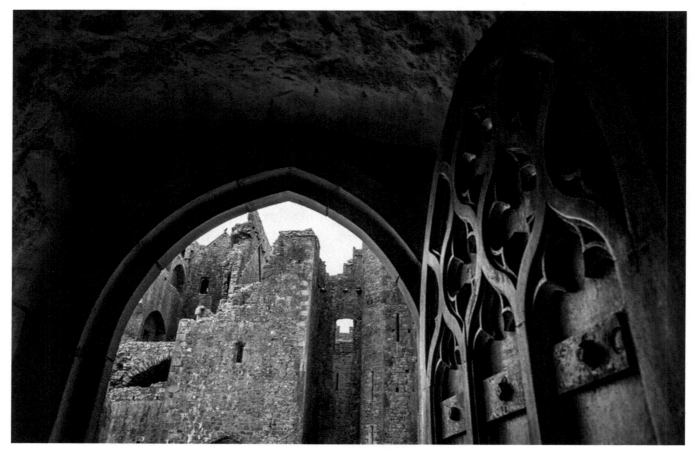

Ally McKay

Take Action—Go out and photograph a subject using the various rules of composition. Be sure to use rule of thirds, leading lines and curves.

Do not forget about the 360 degree rule. Go out and find a subject, then explore that subject. After you are done, do a 360 degree turn and see if anything else around you would make a great subject.

The Power of Flash

One of the aspects of photography that amateurs fear the most is the use of a flash. The misunderstanding of placing an alternate light source on a camera and thinking they are going to add too much light, or not enough, usually leads to people keeping their flash in the bag and hoping for the best with the natural light available to them. The thought that "natural" light is always best prevails and people go about taking their images never utilizing a great tool available to them. YES, beautiful, natural, soft light is always a great option. Yet, photographers should never avoid using an alternate light source when it can be of value. There are many times when the use of a flash can truly help your images. This is not only true when it is too dark, but a flash can really help your images even when there is enough natural light available! Here are just a few examples of where and when a flash helps. We will look at all of these examples in depth.

- When a long exposure has too much movement for a good image.

- To avoid "red eye" from the built in flash

- To brighten eyes and skin even in daylight

- To allow the use of a lower ISO

- To allow the use of a faster shutter speed

- To add light to a dark subject

- To help create even light when a subject would be dark if the exposure for the background is used.

- To create images where the shutter is dragged after the flash for incredible artistic images combining both the flash and natural light elements.

Flash Overview

People will say to me all the time, "I don't like flash, I prefer natural light." Usually, what that means to me is that they simply do not understand flash and how it works and how beneficial it can be. The flash is one of the best tools in your bag, when needed. After you read through this chapter, you will see my K.I.S.S. (Keep it Simple Stupid) method for how to use flash that works every time. Don't let flash scare you any longer!

Let's start with how a flash works and different ways to control it. Simply put, you use a flash anytime you need to or want to add more light to a situation. This can be for a variety of reasons, such as those listed above. Start thinking of your flash as that friend you may have that you call once in a while when you have a favor to ask who is always there for you! A flash can be a great friend!

The best flashes are like most items in photography, the more expensive ones. Where I think you can get by with "off brand" lenses and other items in photography, a flash is one of the items I always recommend purchasing as a name brand of the camera that you have.

For instance, if you own a Canon, I recommend a Canon flash. If you own a Nikon, I recommend a Nikon flash and the same with any camera on the market. There are alternatives brands that will work on all cameras if purchased for your camera make. These brands such as Metz and Sunpak and others are good, and will work if purchased for your camera.

However, in my experience, I have found that the name brand flashes built for a system "talk" to each other best. This means that when you place a Canon flash on a Canon camera, immediately, the camera goes, "hey, I recognize you and we can work together easily!" With other brands the camera says, "I'm not so familiar with you—Who are you and where did you come from?" In my opinion, it just seems that the manufacturers have really nailed the communication within their own systems and this is a good thing, but it does cost a little more.

I recommend that you purchase a flash that has the ability to tilt its head vertically. This means that you can control the direction of the light by tilting the top of it towards the ceiling. I also recommend you purchase a flash with a head that can rotate. In doing this, you have much more control in the direction of your light. Many of the less expensive flashes only allow their light to be directly aimed at the subject. Soon, you will see why I like flashes with more control.

Canon basic flash with no tilt or rotate ability

Nikon flash with full tilt and rotate capability.

As you can see from the examples above, one flash is also quite a bit larger than the other. All camera manufacturers make a series of flashes for their cameras and they range by price, due not only to their tilt and rotation capabilities, but also to how much light they produce. Accordingly, the more expensive the flash, usually the more powerful it is as well.

I don't think that you always need the most powerful flash (although it doesn't hurt), but for the best results, I feel that being able to tilt and rotate is very important, as you will soon see from our examples.

The Basics

Let's start to understand the basics. First when you use a flash and depress the shutter button, the image recorded is ALWAYS a combination of the flash AND the existing light available. As the shutter opens and exposes, the flash goes off and is being recorded. At the same time that the shutter is open, natural light that is available is also being recorded. This is extremely important to understand as you are now combining light sources and have one more element of light to control.

By working with your aperture, ISO and shutter, you still control the amount of ambient light being recorded just as without a flash. Just like without a flash, the shutter time still represents the amount of time ambient light is allowed to record to the sensor and the aperture (lens opening) determines how much light has access to the sensor.

Remember, the longer the shutter speed, the longer it stays open to allow light in and the wider the aperture opening, the more the amount of light. However, now you are adding an alternate light source by bringing in the flash. This will allow you to have more light when needed as well as to fill in light when necessary.

Your images, when flash is in use, are directly affected by DISTANCE. The closer you are to a subject, the brighter it will be illuminated with a flash and therefore the light (both flash and ambient) needs to be controlled.

Cameras have what is known as a maximum sync speed for flash. This means, that when the shutter opens and the flash fires, the flash will be over by the time the shutter closes. If you set your shutter too fast (usually above 1/200 or 1/250 on most cameras), your flash will not sync since the shutter is closing before the flash is finished illuminating the subject. This means that the shutter actually opens and closes faster than the flash can record. Your result will be a black line on the side of your image.

To avoid this you can only set your camera's shutter speed at its maximum sync speed or slower. Again, most cameras are around 1/200 or 1/250 of a second. There is an exception to this situation. This is known as "high speed" sync and can be very useful if you need to photograph with a fast shutter to help record the action. Many flashes have this capability, but they have to be bought with this in mind. This is a situation where, in my opinion, having the manufacturer made flash really helps as the camera and flash know how to talk to each other properly. Having a high

speed sync flash setting will allow you to move your shutter much faster than the original sync speed. Personally, I love having this available as it has proven to be very helpful a few times while on assignment.

Once you have purchased your flash unit, it's time to practice again! As previously mentioned, the ability, in a digital world to see our images instantly is an amazing learning tool. We can shoot and then adjust immediately.

TTL vs Manual

When using a flash, there is a system known as TTL (Through The Lens) available that can be used in place of manual settings on the flash unit. When the shutter is fired, the flash goes off and travels to the subject as a beam of light. This beam of light than travels back "through the lens" and to the camera sensor where the camera software talks to the flash and determines for you the right amount of light needed for the correct exposure regardless of your aperture setting.

This can be a great help especially if you are photographing an event such as a wedding where the distances of the subject change rapidly. TTL technology has only recently become very good in my opinion with new flash systems and software. With TTL technology, the camera's computer will provide the correct exposure regardless of the aperture setting or flash-to-subject distance (as long as the subject is within the realm of the flash's power).

You can pick the aperture for the desired depth of field and not have it preselected by the flash to subject distance. In the past, you had to determine the flash to subject distance for your exposure first and then do the best you could with depth of field. Now, you can choose the aperture you would like and the camera's computer will provide you with the correct exposure.

The question that remains is this: is it always best to use TTL technology? The answer is no. Many times it is a fantastic tool. There are the times though when you will find that by placing your flash on full manual, you will get better results as you can determine exactly what you want. I use both and it depends on the situation and the results I want to achieve. I have found TTL to be a great help in some situations while in others I have found going to full manual is a better option.

How to Use Your Flash on Manual

K.I.S.S Step by Step Flash Procedure:

1. Expose for the background using ISO 100 (400 with pop-up flash)

2. Leave the flash on full power and on manual

3. Use the aperture to control how light or dark the subject is. If the subject is too light, take the f-stop to a larger number (smaller opening). Do the reverse if the subject is too dark.

4. Use the shutter to control the natural ambient light. Start at 1/125th of a second. Make the shutter speed slower if you want more natural light to show. If you want the background to be

darker, make the shutter speed faster. A flash with high speed sync will allow you to go faster than 1/200th of a second.

5. Fine tune your adjustments! If you find the subject is still too dark, and you have opened your aperture as far as it will go, bump the ISO higher.

Let's start by using a flash when it is dark, either in a room or outside. When you are trying to make an exposure and you have no flash, as I have taught, you usually need to adjust your ISO much higher because there is not enough light available to create the image unless you do a long exposure. By utilizing a flash, we are bringing in light. With this is mind, we can now go back to using a better quality ISO such as 100 or 400. The more powerful the flash, the more light you have to work with which means you can use a better ISO for quality purposes.

I have seen many times where students of photography have learned to use a high ISO when there is not much light, but fail to realize that with a flash, you now have light, therefore you can go back to a better quality ISO! This is a great help for images that would otherwise contain too much noise.

I always try to use the best ISO possible in any given situation. With our flash units that are very powerful, I am usually able to shoot with an ISO of 100 or 400, depending on how far away I am from my subject. Remember, with a flash, the light source is based on distance from the subject. The farther away, I am, the less light is reaching the subject and I have to increase the ISO to help create the proper exposure. You will only be able to determine these factors by testing your flash with a subject at varying distances and by playing with your exposure. Yes…it takes practice!

In using a flash, try to avoid aiming the flash directly at the subject. When a flash is aimed directly at a subject you do have more light hitting them. This would seem good; however, it tends to create very harsh lighting conditions. The on-camera flash is notorious for this!

When a flash is aimed directly at a subject with eyes, such as a human or an animal, many times you will get "red eye". The effect of red-eye happens more when the flash is closer to the lens and is the result of a reflection of blood behind the pupil in the eye. Kind of gross huh?! You can avoid this in a few ways. I recommend tilting your flash head up and "bouncing" the light off of a ceiling and down on your subject if you are indoors and the ceilings are not too high. This creates a much softer light and avoids red-eye as well as the harsh lighting issues.

Now when you do this, the flash has to travel a greater distance. Rather than traveling directly to your subject, it is being bounced off of a ceiling. Therefore it is traveling to the ceiling first and then down to your subject.

In order to get the proper exposure, try opening your aperture wider or your shutter longer to allow more time and available light on your subject. For example, let's say that you have a subject ten feet from you. You are shooting at an ISO of 400 with a flash on the manual settings. You are shooting with the flash directly at your subject and the exposure is 1/200 of a second at f11 and

works. However, your subject has a big harsh shadow created from the flash and has that "deer in the headlight" look because the light is so harsh. Now, bounce your flash by tilting it up at a forty five degree angle to the ceiling.

Remember, the time the flash travels to your subject has just doubled because it has to go to the ceiling first. So, open up your aperture from f11 to f5.6 as you are now allowing more available light into the sensor by opening the lens wider. If you take the image and it's still too dark, try adjusting further. However, maybe your lens only goes to f5.6. That's ok because we still have other options! Now try making the shutter speed longer.

In doing so, you are allowing the light from your flash more time to travel to your subject or, in other words, changing the sensitivity of the amount of light needed! Again, you have to start and then try and by making adjustments, find the best exposure. What if that still wasn't enough at say 1/60th of a second and you are now worried about camera shake if the shutter is open for too long? You are out of room on your lens with the f-stop/aperture range, so what can you do? It's the same as without a flash! Adjust your ISO. If you were shooting at 100, try 400. Now you do not need as much light because the sensor doesn't require as much at 400.

The important part of all of this is to start and keep working at it! With flash photography, I do everything I can to avoid aiming it right at the subject, as I mentioned, but in doing so, you may have to work a little harder with your settings to find the right exposure. It's worth it!

Now if you are outside and you can't bounce the light there are also options. By placing a "dome" on your flash, you can soften the light beautifully. Just as bouncing a flash goes, you are now going to need to make adjustments because by placing this over your flash, the light is diffusing and spreading out. In this way, it is not nearly as harsh on your subject.

Look at these examples.

Straight flash. Notice the shadow and harshness of the light.

This is using a Gary Fong "dome." Notice how much softer the light is and the shadows are gone!

You can adjust the tilt of your flash straight up and the flash will still hit your subject as it is being contained and then diffused out. We use the dome diffuser quite a bit because the results are so nice and soft. If you are photographing your subject vertically, try rotating the head upwards so you are still bouncing the flash off of the ceiling. This is where the ability to tilt and rotate really helps. Even when there is plenty of natural and ambient light available, I find that this truly enhances skin tones and gives needed light to the eyes.

In the example below, there was plenty of ambient light, but by adding a little flash even when there was plenty of light, we created a much better portrait.

In the image above, out subject had plenty of available light and looks nice.

In this image, by using a little flash, we have brightened her eyes, created a much nicer skin tone, and added just a little more life to the image.

Fill Flash

Adding a flash when a subject is dark against a back lit area such as a sky or sunset is known as "fill flash". The idea is to fill the image with a little more light where your background is really bright and the subject is in shade in order to even the light out. With just natural light, if you expose for just the subject, your background will be completely blown out and over-exposed. Reverse that and expose for the background and your subject is completely dark. The idea here is to be able to have a bright background with a good exposure and by adding light to your subject; you are bringing the subjects exposure into the range of the background exposure. Once again, you are "filling the subject" with light.

Many times people avoid shooting into the sun because it is so bright. In this situation I would suggest bringing flash in to even out the light.

The image is too bright with the sun behind the subject.

When exposing for the background, our subject becomes too dark.

By adding a fill flash we can even out the light so that the exposure on the subject and on the background is the same. In the image above, it allowed the sun to be used as beautiful hair lighting for her hair!

In this exposure above of Ally at 1/160th of a second at f4 the flash power was good and distance was good. However, because the shutter was open longer, the ambient light of the sky became really bright.

Now, by taking the shutter speed to 1/400th of a second and not allowing as much ambient light in, the sky became the beautiful rich tones we were seeing with our naked eye. We kept the aperture the same at f4. You can see how just a little difference in the shutter speed with the ambient light that was being recorded—made a huge difference in the image! This was photographed using the dome.

Once we took the time to nail our exposure, we then brought in our subjects, and look at the amazing image we got.

1/400th of a second at f4 ISO 400

Dragging the Shutter

Another concept in using a flash is the ability to "drag" your shutter. This simply means that you use the flash to light your subject initially and then, by having a long shutter, the ambient light is being recorded. This is perfect for situations where there may be beautiful lighting at night, but, without a flash, your subject would be dark.

½ of a second exposure at f4.5 ISO 500

The flash allowed our subjects to be lit, but the long exposure allowed the beautiful ambient light behind them to come through. If we had done a shorter length exposure with the shutter by increasing the speed, such as 1/125th of a second, the subjects would still be lit well because of the flash. HOWEVER, the shutter speed would not have provided enough time for the beautiful

ambient light to come through. Notice that, because it is a long exposure, you can see Ally walking through my shot above! She is like a ghost because she is moving during that long ½ second exposure!

¼ of a second at f4.5 ISO 500

1 second at f2.8 ISO 400

Once again, the long shutter speed allowed the ambient light of the bridge to come through. Remember, when using a flash, you are not only recording the light from it, but also any ambient light. Once again, this image could have been done using a much shorter timed exposure and Ally still would have been lit well by the flash. However, the ambient light of the bridge would have been lost. When doing these long exposures, a good tripod really helps to steady the camera.

1/13th of a second at f4 ISO 500

Notice in this image that the band is walking. The flash fired and captured them, but as they walked they had some motion "blur" that was recorded from the ambient natural light. This is just one example of using flash and natural light to achieve very dramatic results.

1/10th of a second at f4 ISO 500

Flash can be difficult to grasp at first. However, with practice and time, as we mentioned earlier, it can become that friend you can call upon at any time that will help you when needed! Don't leave

your flash in your bag. You are not going to use it all the time, but remember, it's there and use it to add light when needed or to enhance your subjects. Follow the simple flash steps listed again below and you will find that flash will become a great tool in your camera bag in your photographic arsenal!

Step by Step Flash Procedure Again

Expose for the background using ISO 100 (400 with pop up flash)

Leave Flash on Full power on Manual

Use the Aperture to control how light or dark the subject is. If the subject is too light, take the F Stop to a bigger number (smaller opening). Reverse if subject is too dark.

Use the Shutter to control Natural Ambient light. Start at 1/125th of a second. Take the Shutter longer if you want more natural light to show. If you want the background darker, take the shutter faster. A flash with High Speed sync will allow going faster then 1/200th of a second.

Fine tune adjustments! If you find the subject is still too dark, and you have opened your Aperture as far as it will go, bump the ISO higher.

Take Action: Use your flash! Even if you just have the pop-up flash on your camera, go ahead and try it. Try dragging the shutter in situations where the shutter speed is slower and the flash hits your subject, but the background lights also come in well in the exposure.

Assignments

First, I would like to say CONGRATULATIONS! If you have read through this book, and have done the "Take Action" step assignments along the way, you should be well on your way. You are already starting to take amazing photographs using all of the new creative control you have gained! In this section, I am going to give you some additional assignments that should help solidify what you have learned. That is exciting and from here you should continue to grow in your photographic journey. You are ready for Volume 2 of this series which will be published soon. Stay tuned as that will contain all kinds of new, wonderful, FUN assignments and step by step instructions!

Assignment 1—Same Subject, Different Perspectives and Times of Day.

One of the best ways you can really get a handle on photography is to take a single, simple subject and photograph the same subject at different times of the day, using different focal lengths of lenses, and working to get as many unique images as you can of the same subject. By shooting at various times of day, you get different light, which translates to different exposure values. Different lenses create different perspectives. Use the move your feet rule. Get creative. Use different settings for depth, composition etc. Press yourself to get creative when it doesn't seem like you can get a good image!

The SAME tree with various lenses, times of day and compositions.

Assignment 2—Same Scene, Different Images!

In this assignment, I bring you the challenge of photographing the same location but coming up with two totally different and unique images. How is this accomplished? Please do not say PHOTOSHOP!!!

Although you are welcome to use Photoshop in the process of enhancing your different images to create even more dynamics, I would like you to actually photograph from the same spot in different lighting, days, moods or whatever else you can think of.

Sounds simple, huh? Well as you will find, the simplicity of the same location, brings with it the difficulty of creating an interesting image. For instance, maybe the location you choose is great in early morning light, but the image doesn't really make sense during the rest of the day. Maybe the weather is great one day and not so great the next. Maybe your image would be best served taken at night, but during midday the image looks harsh and washed out. This is the challenge!

Now here's the catch, you must shoot on two DIFFERENT days. Let's see what you can come up with. If you go to the location on one day and it doesn't look great, go back again!

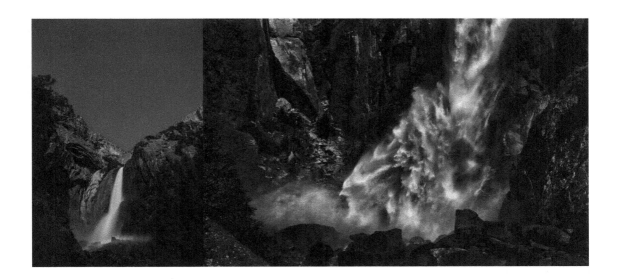

Image 1 – Lower Yosemite Falls at midnight with a "moonbow." 30 second exposure!

Image 2 – Lower Yosemite Falls midday close up. 1/4000th of a second.

Assignment 3—Capture Fast Action

Making your shutter speed your priority, photograph fast subject matter. Be sure to get your shutter speed up high to stop the action. Start by setting your shutter speed at a high number such as 1/1000th of a second. Adjust your f-stop to line up the light meter. If you find you do not have enough light, increase your ISO until you are able to get the meter centered up. Experiment with various fast shutter speeds from 1/500th of a second to as fast as yours will go, such as 1/4000th of a second. If you are struggling to gain proper exposure, place the mode dial to shutter priority (S or Tv) and set your ISO to auto (only your ISO) to help nail it down.

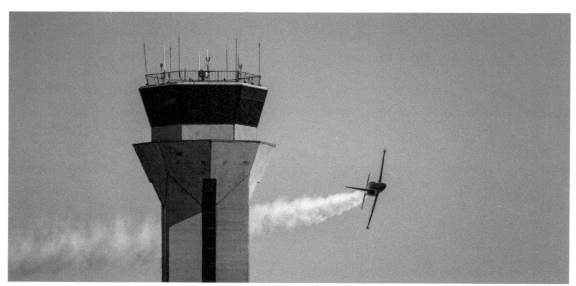

1/4000th of a second.

1/8000th of a second.

Assignment 4—Blur the Action

In this assignment, reverse Assignment 3. You will need a tripod to do this properly! Your ISO should be set at 100 and then start by taking your f-stop to the biggest number (smallest opening) your lens will go, such as f22. This will force you to use a longer shutter speed to make the exposure. If you want to go really long on the exposure, do this at dusk or use an ND filter (a filter that takes away light) to accomplish longer shutter speeds. Try doing light streaks like in the image below!

30 second exposure

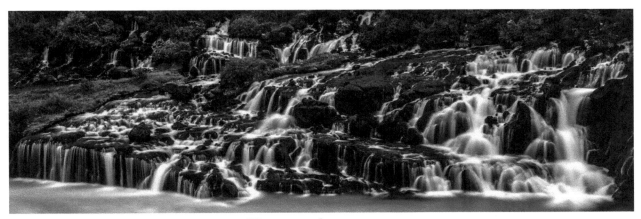

20 second exposure

Assignment 5—Depth of Field

In this assignment photograph both a shallow depth of field image and a deep depth of field image. Remember, the small number f-stop is for small depth. The big number is for big depth. Try to shoot both! Also, remember that the closer you are to a subject, the easier it is to get a shallow depth of field. For this reason, you can also zoom in on a subject that is further away and find it is easier to obtain the shallow depth.

f4

f22

Assignment 6—Animal Photography

Lions and tigers and bears…oh my!

Animals are a wonderful subject, and photographing them is a great learning experience. Whether you are in the wild, photographing your pet, or at a zoo, animal photography is great fun, but also presents many challenges.

Take time to go out and search for great animal photography opportunities. If you have not been to the local zoo or wildlife park lately, this is the perfect chance to get out and use your skills.

When photographing animals, if it is not your pet, you almost always need a telephoto lens for obvious reasons. If you do not have a long telephoto for this assignment such as a 70mm-200mm or even longer, make sure to rent one.

As always, lighting is the key. If you are out in the middle of the day with harsh light, your images will reflect that quality of light. Early morning soft light is great and late evening light can be dramatic and beautiful. Make sure not to photograph your subject in uneven lighting where there are a lot of shadows or spotty light. Generally, this should go for any subject you photograph at any time.

One of the issues you may notice if you are photographing your dog for example is how hard it is to get a good depth of field. Usually, it is best to focus on the eyes, but you need a decent depth of field to get the long nose in focus as well. Try shooting on at least f8 for good depth from the nose back.

Of course, this may mean that you can't get the shutter speed you need if Fido is unwilling to pose for you! So, if that is the case, bump up your ISO. You will need a pretty fast shutter speed most of the time.

When photographing a fast moving subject that is going in and out of different light, go ahead and use your shutter priority mode. Set your shutter at a speed that will get your action stopped, but again, watch where the camera is setting your f-stop. If it is too low a number, you will have an issue with depth on the animal's face. If this is the case, bump your ISO up as well. Typically, because you need BOTH a fast shutter speed AND a high depth of field such as f11, or higher, you will find you will need a higher ISO, if the light is not too bright, to compensate as the fast shutter and high f-stop do not allow much light in.

Assignment 7—Leading Lines and Curves

Go out and shoot several leading lines and curves that lead your viewer on a journey through the image. Pay close attention to your rule of thirds. Notice that in these three images, all of them have used the thirds properly.

Assignment 8—Drag the Shutter With a Flash

Take a night-time photograph of a person or group of people with lights behind your subject, such as Christmas tree lights or a lighted building. Photograph your subject using a flash by setting your ISO at 100 (if it's a built in pop-up ISO 400) and use the f-stop to control how light or dark the subject is and use your shutter speed to determine the desired result of the background lights.

1/8th of a second at f4 ISO 100

Bonus—Images and Settings Used!

ISO 400 **1/100th** **f9** **Iceland**

ISO 500 **1/320th** **f16** **Iceland**

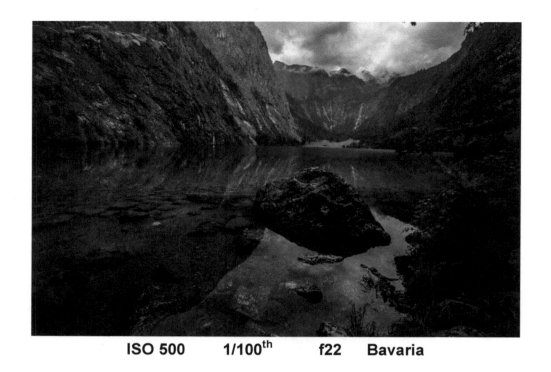

ISO 500 **1/100th** **f22** **Bavaria**

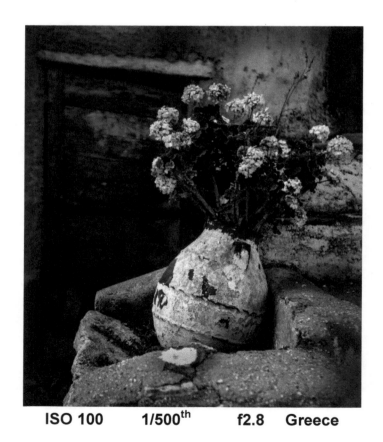

ISO 100 **1/500th** **f2.8** **Greece**

ISO 1600 1/250ᵗʰ f2.8 Needtobreathe-Red Rocks

ISO 2000 1/2000ᵗʰ f3.5 Don Felder-Red Rocks

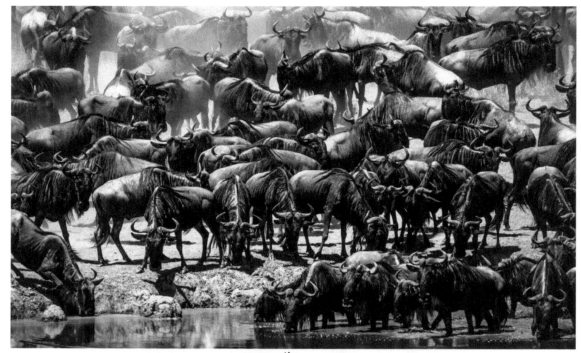

ISO 400 1/1250th f6.3 Tanzania

ISO 640 1/125th f22 Tanzania

Acknowledgements

There were so many awesome people who inspired me to write this book and helped continually improve it. Thanks for your support and for helping to make this book great!

Ally, you have supported me and told me to "go for it" with writing. Thank you for who you are and your love and support of me.

Thank you for your inspiration as a photographer and for your contributions to this book.

Nick and Steve. You are some of the most awesome instructors and people I know. Thanks for taking the journey with me!

Toby, you continue to show the world your love for photography and education through your awesome YouTube channel Photorec.tv

Thanks for coming along with MPA. *Let's keep going!*

Chandler, Sean and Self-Publishing School, thanks for pushing me to make my dream of writing a reality. Here it is and cheers to more books to come!

Mariah for being the best accountability partner on this project!

R.E. Vance—Self Publishing School coach extraordinaire! INVALUABLE!

About the Author

David, along with his wife, Ally, owns and operates McKay Photography Academy and McKay Photography Inc.

The academy leads tours, classes, and workshops throughout the world. Their studio is known for high-end artistic portraiture.

David holds the degrees of Master of Photography, Craftsmen and Certified from Professional Photographer of America.

David lives in El Dorado Hills, CA just east of Sacramento and has been a professional photographer for over 29 years.

Visit the academy web site at www.mckaylive.com

Connect with the McKay's

- Facebook—https://www.facebook.com/mckayphotographyacademy

- Instagram—#mckaylive

Learn PERSONALLY with David and Ally and their awesome team on a photography tour!

Check out http://mckaylive.com/photography-tours

Please be sure to check out the next book in the Photography Demystified series!

Your Guide to Exploring Light and Creative Ideas!

Check out these reviews!

Who would have thought that someone could produce not just one fabulous photography book, but bring out a second with even more powerful educational material. From the beginner to the pro, everyone will find insightful, knowledgeable, and educational material presented in what has become the David McKay style of clear, concise instruction on methods and equipment that make the stunning images that he produces, come to life in your camera. This is another Number One. - Don T

This book by David McKay is very user friendly. It's an amazing guide to have for any photographer. I've taken very expensive classes to learn this type of information and to have it all in writing is so handy and priceless. He talks about gear...having plenty of formatted memory cards, have your camera settings ready, batteries all charged, tripod, etc. Dave also talks about lighting...sunrise & sunset (I loved the advice of look at what the light is doing-not just the actual sun), reflections, movement of water, fireworks, street photography, portraits and more. He gives incredible photography tips on how to get that gorgeous blue sky at night time after a sunset. David is so inspiring. He gives several examples of his own beautiful work from all over the country. The way I learn is actually doing the work so this book is perfect because after each subject, there is "Take Actions" where Dave gives you everything you would need to actually go practice what you were just taught. This is an incredible book that can take you to the next level. - Smokey

Recommended Resources

www.Photorec.tv

www.youtube.com/user/camerarecToby

An awesome web site and YouTube channel with our friend Toby Gelston

TONS of content and TONS of gear reviews and help!

www.thinktankphoto.com/pages/workshop?rfsn=141206.b44047

Best camera bags we have ever used! LOVE them!

WHAT GEAR DO YOU NEED?

Let us ship it right to your door, business or hotel!

TAKE 10% OFF ANY RENTAL OF $125 OR MORE

Use Code:
DEMYSTIFIED

All prices include roundtrip standard shipping. Only valid on rentals. Cannot be used to purchase used gear listed for sale. Cannot be used with any other coupon.

Our favorite gear rental company!

www.spiderholster.com

Great way to handle your camera! One of my favorite new items I use!

If you want to become an author ... like I have....

But you're terrified of staring down a blank page....

This free video training course might be just the thing you need.

See, it's intimidating when we have to start from scratch.

We know we want the end result—a book with our name on it or passive income checks, authority, or a booming business.....

But as soon as we get that mental picture of a published book, we get overwhelmed.

It's like the first time we drove a car.

It seems like there are a thousand things going on at once.

What's that person doing? Do I need to put on my turn signal? What are my feet supposed to be doing? Which way do I turn?

But with help, driving becomes second nature. We could do it in our sleep.

What made the difference? We learned a system so we knew exactly what to do at each step.

Turns out the same thing happens with becoming an author, except most people spend years just trying to figure out how to get their book into first gear.

That's why my friend Chandler Bolt put together a free video course to guide you every step of the way as you go from "no idea" to bestseller—a free gift to you.

Watch the video course: https://xe172.isrefer.com/go/firstbook/dmckay22

Chandler is a college dropout who went from C-minus English student to 5X bestselling author. He's even built a business that's breaking 7 figures—in under 2 years.

But he wasn't "lucky" or "brilliant" or just "born that way."

He wasn't even a good writer, which is great news for the rest of us.

See, you don't need tons of raw talent or the perfect idea or a ton of time.

You don't need an elaborate plan with 50 moving parts. (I'm talking about the blogs that shout "Top 100 things you can do to promote your book!")

And you don't need to spend years fighting and struggling.

Because Chandler figured out a better and faster way to become a bestselling author—even use your book to build your business, brand of following.

His solution isn't elegant.

It won't amaze you with its complexity, either (there are only 3 steps to the whole process).

But it works.

And I want to share it with you for free.

Watch the course now: https://xe172.isrefer.com/go/firstbook/dmckay22

If I can do it, YOU CAN DO IT!

—David McKay

P.S. Hundreds of people are tackling their books using this 3-step FREE video course, "From 'No Idea' to Bestseller." Join them now.

https://xe172.isrefer.com/go/firstbook/dmckay22

Urgent Plea!

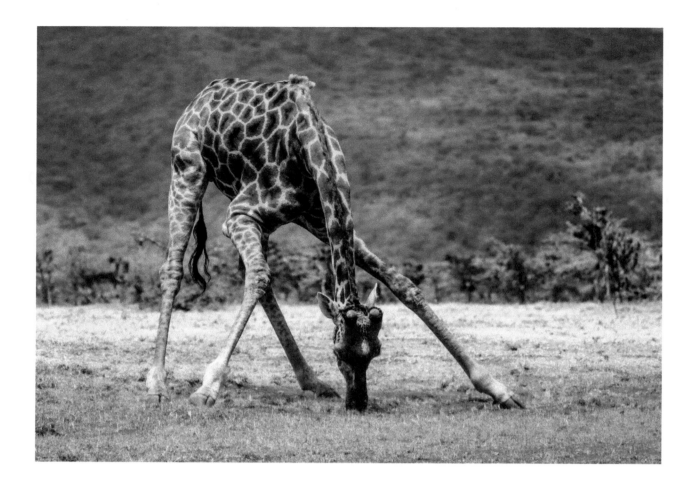

Thank you for downloading our book! We really appreciate all of your feedback, and we love hearing what you have to say.

We need your input to make the next version better.

Please leave us a helpful REVIEW on Amazon on my book page!

http://bit.ly/photographydemystified

Thanks so much!!
~David McKay

CPSIA information can be obtained
at www.ICGtesting.com
Printed in the USA
BVHW021422200919
559004BV00017B/1130/P

9 781945 176968